Sports Memories of
Western Pennsylvania

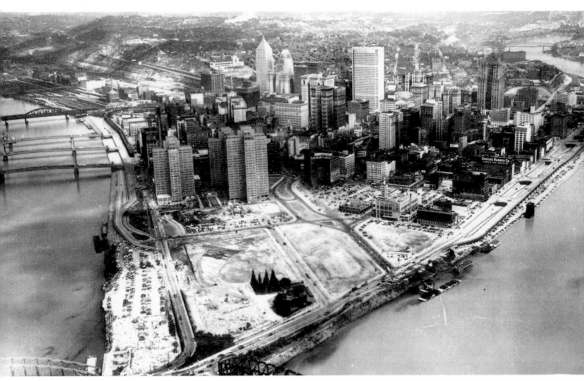

Is there something in the water? Many have speculated that somehow the waters of Pittsburgh's famed three rivers—the Allegheny, the Monongahela, and the Ohio—worked like a magic potion to spawn some of the greatest athletes of all time. This undated photograph shows a classic view of Pittsburgh, a place with a rich history, many great sports stories, and an area that has savored the glory of five Super Bowl championships, five World Series titles, and two Stanley Cups. It is a region with a high school football tradition that has produced nearly 50 professional quarterbacks, including six who were inducted into the Pro Football Hall of Fame. Western Pennsylvania also hosted the first professional football game, the first World Series, and a superior Negro League tradition. These stories are all part of the Western Pennsylvania region's evolution as a sports leader for over more than a century. (Courtesy of Photo Antiquities Museum of Photographic History.)

On the front cover: Please see page 41. (Courtesy of Photo Antiquities Museum of Photographic History.)

On the back cover: This photograph shows an aerial view of Pittsburgh, nicknamed the "City of Champions" because of its long and rich association with success in sports. (Courtesy of Photo Antiquities Museum of Photographic History.)

Cover background: Along with the Homestead Grays, the Pittsburgh Crawfords, seen here in this classic photograph, characterized the glory of Negro League baseball in the 1930s. The 1935 Crawfords, with five future hall of famers, are considered perhaps the greatest baseball team ever. (Courtesy of Photo Antiquities Museum of Photographic History.)

SPORTS MEMORIES OF
WESTERN PENNSYLVANIA

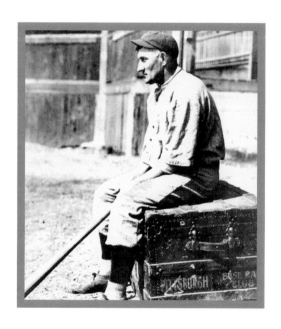

Lisa A. Alzo and Alby Oxenreiter

ARCADIA
PUBLISHING

To my wife and three children, and to my parents, who raised their 12 children on love, and with a love of sports.
—*Alby*

In loving memory of my father, John "Whitey" Alzo, an outstanding basketball player and an even more remarkable man.
—*Lisa*

Copyright © 2007 by Lisa A. Alzo and Alby Oxenreiter
ISBN 978-0-7385-5037-4

Published by Arcadia Publishing
Charleston SC, Chicago IL, Portsmouth NH, San Francisco CA

Printed in the United States of America

Library of Congress Catalog Card Number: 2007922171

For all general information contact Arcadia Publishing at:
Telephone 843-853-2070
Fax 843-853-0044
E-mail sales@arcadiapublishing.com
For customer service and orders:
Toll-Free 1-888-313-2665

Visit us on the Internet at www.arcadiapublishing.com

CONTENTS

ACKNOWLEDGMENTS

We are grateful to the following individuals and organizations for their help in obtaining the photographs that appear in this book: Keith Abbott, John A. Alzo, Todd Augenstein, Elizabeth Banzen, the Benedict family, Leslie Wagner Blair, George Blanda, Corey Bower, Maraleen "Fudge" Browne, Dan and Sarah Burns, Tricia Cavalier, John and Helene Cincebeaux, Tim Conn, Myron Cope, Joe Dorcak, Tony Dorsett, Duquesne University, Regina Feryok, Mike Gallagher, Kate Grannemann, Bill Hillgrove, Marilyn Holt, James Klingensmith, Mike Lange, Mario Lemieux, Helen Lizanov, Jim Kelly, Dan Marino, Miriam Meislik, Bob Metz, Joe Montana, Joe Namath, Arnold Palmer, Gilbert Pietrzak, the Sivak family, Bob Trombetta, Frank Watters, Scott Yoss, Lauren Zabelsky, Carnegie Library of Homestead, Carnegie Library of Pittsburgh, McKeesport Daily News, Michigan State University Sports Information, Mifflin Township Historical Society, Oakmont Country Club, Photo Antiquities Museum of Photographic History, Ringgold High School, the Historical Society of Western Pennsylvania, the Library of Congress, the Pittsburgh Courier, the Pittsburgh Penguins, the Pittsburgh Post-Gazette, the Pittsburgh Steelers, the Senator John Heinz Regional History Center, the University of Kentucky, the Willie Thrower Foundation, University of Pittsburgh Archives Service Center, and others we may have inadvertently overlooked.

We also wish to thank our respective spouses and families for their love and support, and Norman "Mickey" Abbott and Ed Blank for bringing us together for this book.

Finally, we would like to thank Tiffany Howe, our editor at Arcadia Publishing, for her patience in shaping this project, and for her expert guidance.

While writing this book we had the difficult task of deciding which photographs to include from the endless possibilities that came our way. Unfortunately, due to space limitations, and other restrictions, there were many photographs of sports figures, teams, and events that we regrettably were unable to include. Nevertheless, with the nearly 200 images eventually selected, *Sports Memories of Western Pennsylvania* is a salute to the athletes, coaches, announcers and fans, who together created a rich sports history for western Pennsylvania. The following sources were used in writing this book:

Finoli, David, and Tom Aikens. *The Birthplace of Professional Football: Southwestern Pennsylvania.*
 Charleston, SC: Arcadia Publishing, 2004.
sports.pghhistory.org
www.billyconn.net
www.baseballhalloffame.org
www.clpgh.org
www.hoophall.com
www.hhof.com
www.loc.gov
www.pitt.edu
www.profootballhof.com
www.uky.edu

INTRODUCTION

Having grown up in western Pennsylvania, and having covered amateur and professional sports in the region for nearly 20 years, I am truly honored to have the opportunity to write the introduction and to contribute to the content of this book.

It would be difficult to find another area that has hosted as many significant sporting events, seen so many milestone moments, or been home to more world-class athletes and sports figures.

The Pittsburgh region's sports history is deep, and so is the connection between the fans and the area's storied past. This unique relationship has helped to forge a bond and foster a pride between the residents and their sports heroes. In the midst of economic distress, unemployment, and declining population, these sports champions and the moments they defined have given western Pennsylvania a reason to celebrate, and have provided a source of pride for the adoring fans who call western Pennsylvania home.

This is a story that needs to be told and retold for generations to come. It is a story of ordinary people who became extraordinary athletes and world-changing sports personalities who never forgot their western Pennsylvania roots. It is a story of regular competition that, over time, has become part of the historical fabric of sports.

More than 100 years ago, Pittsburgh's Exposition Park was the site for four games of the first World Series. Even though the hometown Pirates lost the series, an American tradition was born. Overall Pittsburgh has been a part of seven of these fall classics, and the Pirates have won five world championships.

Pittsburgh's rich baseball tradition includes Honus Wagner, a baseball icon and a true hometown hero. The Flying Dutchman was one of the original inductees to the National Baseball Hall of Fame. He was also fiercely proud of his western Pennsylvania roots and rose to prominence in the same area where he was born, raised, and died. Wagner was more than a Pittsburgh athlete; he was a "Pittsburgh guy." Wagner died in 1955. Interestingly enough, that same year, a young Puerto Rican began to make his mark in Pittsburgh history and in baseball lore. Roberto Clemente would become the first Latin American to be inducted into the National Baseball Hall of Fame.

Pittsburgh was also home to the greatest teams and the greatest players in the Negro Leagues. By winning championships with such legendary stars as Josh Gibson, Cool Papa Bell, Judy Johnson, Buck Leonard, and Satchel Page, the Homestead Grays and Pittsburgh Crawfords characterized the glory of their league. The 1935 Crawfords, with five future hall of famers, are considered perhaps the greatest baseball team ever.

The region also witnessed both the first African American player to be drafted by the National Basketball Association (Duquesne University's Chuck Cooper) and the National Football League's first modern-era African American quarterback (New Kensington's Willie Thrower).

Long before Heinz Field and PNC Park, the area boasted many famous venues, including Forbes Field, Pitt Stadium, Exposition Park, Duquesne Gardens, Civic Arena, and Three Rivers Stadium. But western Pennsylvania's most famous sports venue may be the world-class golf

layout at Oakmont Country Club, where the sport's most famous golfers have played. The 2007 U.S. Open will be the eighth to be played at Oakmont, and the 17th major championship that Oakmont has hosted. Oakmont is also a stage where another one of western Pennsylvania's sports legends performed. Latrobe's Arnold Palmer is a golf champion with unmatched worldwide popularity. Palmer is perhaps golf's greatest name, its most influential personality, and one of its dominating players. Palmer also represented half of one of the greatest rivalries in sports, and Oakmont is where Palmer's head-to-head battles with Jack Nicklaus came of age in 1962.

Pittsburgh also gave us the legendary Billy Conn, a "blue collar" boxer from Point Breeze who became the world lightweight champion, and who, on a glorious night at Yankee Stadium in 1941, came close to upsetting Joe Louis for boxing's heavyweight title.

Of course, the history of western Pennsylvania sports would not be complete without Art Rooney, his Pittsburgh Steelers, and football's wildest play. Rooney was one of professional football's founding fathers; the Steelers, one of football's legendary franchises; and the "Immaculate Reception," the single greatest play in football. That one play etched Franco Harris in the pages of football history, and the Steelers, by winning four Super Bowls in a six-year span, staked their claim as football's greatest dynasty.

Western Pennsylvania is also famous for its high school football, for its high school football stars, and for its hall of fame quarterbacks. George Blanda, Johnny Unitas, Joe Namath, Joe Montana, Dan Marino, and Jim Kelly all finished their careers at the Pro Football Hall of Fame in Canton. The athletes share another common distinction: all six grew up in the hills of western Pennsylvania.

The region also produced a Heisman Trophy winner. Tony Dorsett was a standout athlete for Hopewell High School before becoming an All-American at the University of Pittsburgh. Dorsett broke the NCAA rushing record, won America's most famous individual sports award, and led the Panthers to the 1976 national championship.

Dorsett's Heisman fame puts him beside another western Pennsylvania athlete. Notre Dame quarterback Johnny Lujack, a native of Connellsville, won the Heisman in 1947. Incredibly, that small town in Fayette County also boasts an Olympic Gold Medal winner. John Woodruff, while a freshman track star at Pitt in 1936, won the gold in the 800 meters at the Berlin Olympics.

Pittsburgh's hockey history is also rich, from the Hornets of the American Hockey League, to the Penguins of the National Hockey League. The Penguins' back-to-back titles in the early 1990s were delivered by hockey hall of famer Mario Lemieux.

But the tradition of sports in western Pennsylvania goes well beyond the major sports. The region's history also includes skull races along the rivers of Pittsburgh, bicycle races through Schenley Park, and late-19th- and early-20th-century cricket matches.

Western Pennsylvania boasts legendary teams, legendary players, special moments, and an unmatched sports tradition. Through stories and photographs, we hope to revisit some of those flashes in time, and to introduce you to the teams and to the trail blazers who carved their achievements on the pages of western Pennsylvania sports history, and who forever changed the landscape of sports in America.

—Alby Oxenreiter

EARLY SPORTS MEMORIES

If one asked most folks in Western Pennsylvania to recall their favorite sports moments from the past 100 years, one would certainly hear about the Steelers 1970 football dynasty, the Penguins' back-to-back Stanley Cup championships, or the "Never Say Die Pirates" of 1979 celebrating their World Series victory to the sounds of the Sister Sledge disco tune "We Are Fam-i-ly!"

Those with a fondness for nostalgia might note the Pirates 1960 World Series upset over the New York Yankees, the University of Pittsburgh's 1937 Rose Bowl Championship, or Arnold Palmer receiving his first "green jacket" at the 1958 Masters.

Certainly all of the above events are instrumental in defining "sport" for Pittsburgh and all of Western Pennsylvania. But the region's sports history began long before the Steelers joined the National Football League in 1933, or even before Honus Wagner earned the nickname "the Flying Dutchman."

From the early scull races along the famed three rivers, to bicyclists pedaling their way through Schenley Park, to cricket matches and golf games, sport has always held a place in the gritty, hardworking atmosphere that defined Pittsburgh and its surrounding towns, especially in the late-19th and early-20th centuries.

This chapter takes a look at some of the lesser-known moments that have their own unique place in western Pennsylvania sports history.

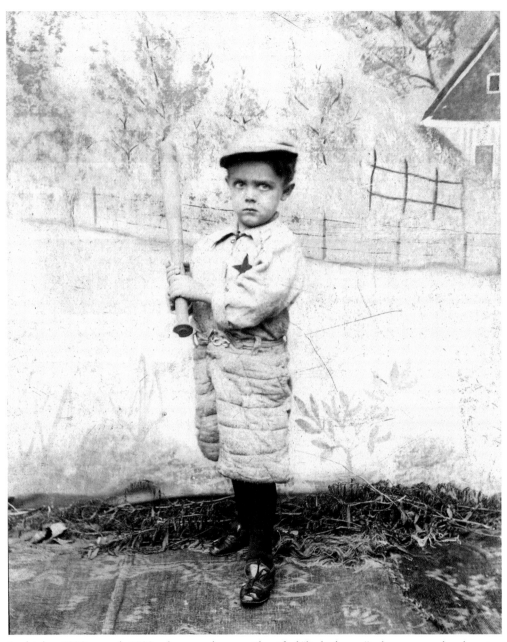

In this late 1800s or early 1900s photograph, an unidentified "little slugger" takes a turn at bat, keeping his eyes focused on the ball. (Courtesy of Photo Antiquities Museum of Photographic History.)

EARLY SPORTS MEMORIES

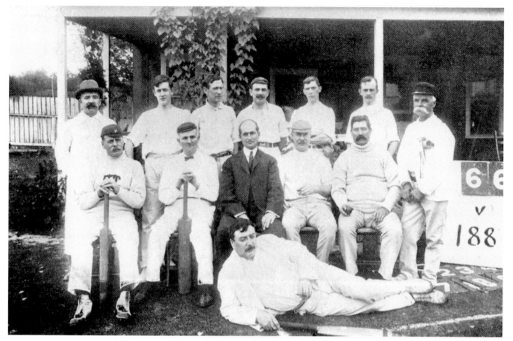

Before baseball ruled, the Pittsburgh Field Club Cricketers, shown here in this undated photograph from the late 1800s, posted a record of seven games won, five lost, and one drawn in 13 matches played. (Courtesy of Carnegie Library of Pittsburgh.)

Located 15 miles from Pittsburgh, the steel town of McKeesport boasted a Star Baseball Club in 1884. (Courtesy of Carnegie Library of Pittsburgh.)

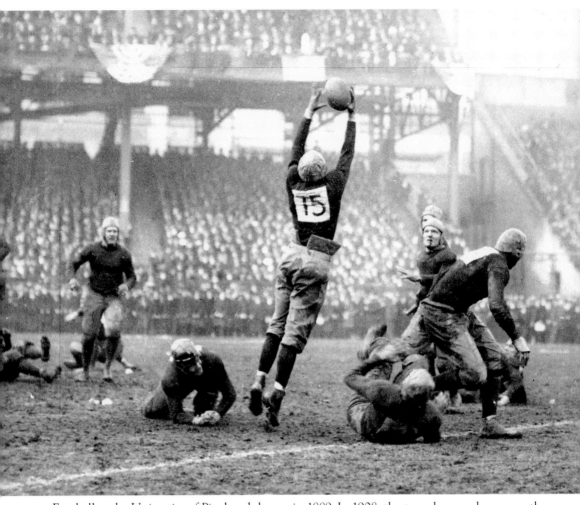

Football at the University of Pittsburgh began in 1889. In 1908, the team became known as the "Pitt Panthers." This photograph showing the team in action was taken by Frank Bingaman. (Courtesy of Carnegie Library of Pittsburgh.)

EARLY SPORTS MEMORIES

Golf came to Pittsburgh in 1893 when John Moorhead Jr., after seeing his first match in Massachusetts, laid out a six-hole, pea can course in the Homewood Race Track. Teeing off is Sarah Fownes (Wadsworth), member of a socially prominent family of golf pioneers and champions. (Courtesy of Carnegie Library of Pittsburgh.)

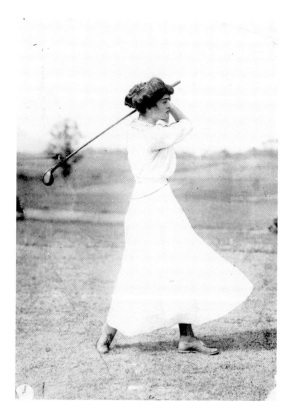

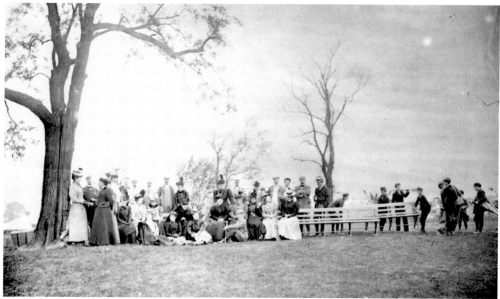

Members of the Pittsburgh Golf Club, which was organized in 1896, are shown enjoying the day. The club's by-laws limited membership of the club to 500 members and stated that the insignia of the club "shall be a three-turreted tower, similar to that on the official seal of the City of Pittsburgh." (Courtesy of Carnegie Library of Pittsburgh.)

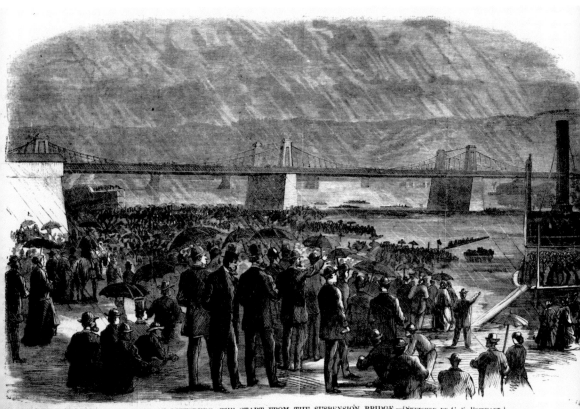

THE SCULL-RACE AT PITTSBURG—THE START FROM THE SUSPENSION BRIDGE.—[SKETCHED BY C. S. REINHART.]

Shown here is a drawing of the scull race between James Hamill of Pittsburgh and Walter Brown of Portland that brought 15,000 Pittsburghers to the riverbank to watch the event in the rain on May 21, 1867. (Courtesy of Carnegie Library of Pittsburgh, Stefan Lorant Iconography Collection.)

Ed Konetchy, baseball player with the Pittsburgh Pirates, stands while holding a basketball in this 1914 photograph. (Courtesy of Library of Congress, Prints and Photographic Division, George Grantham Bain Collection.)

Johannes Peter Wagner was born on February 24, 1874, in Chartiers and died December 6, 1955, in Carnegie. Seen here in a 1904 photograph, he was known as "Honus," "Hans," and "the Flying Dutchman." The following year (1905), Honus Wagner became the first baseball player to have his signature branded into a Louisville Slugger baseball bat. (Courtesy of Leslie Wagner Blair.)

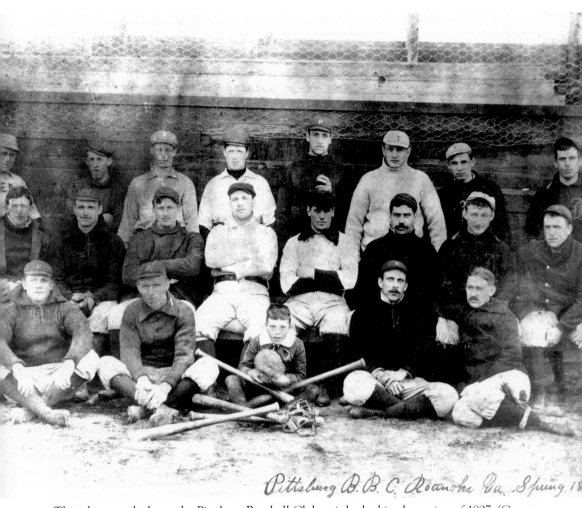

Pittsburg B. B. C. Roanoke Va. Spring, 18

This photograph shows the Pittsburg Baseball Club as it looked in the spring of 1897. (Courtesy of Photo Antiquities Museum of Photographic History.)

"Joe N." is shown at 2:10 at Lexington, Kentucky, in 1905. He was owned by Durbin Horne, and trained and driven by Dave McDonald. The horse won every race in which he started at Brunot's Island and Chicago, driven by J. D. Callery. Harness racing continued to grow in popularity. The Meadows track opened in the 1960s and has been a popular part of Pittsburgh's professional sports scene. (Courtesy of Carnegie Library of Pittsburgh.)

A unidentified rider makes eye contact with his horse while spectators look on in this undated photograph. (Courtesy of Photo Antiquities Museum of Photograph History.)

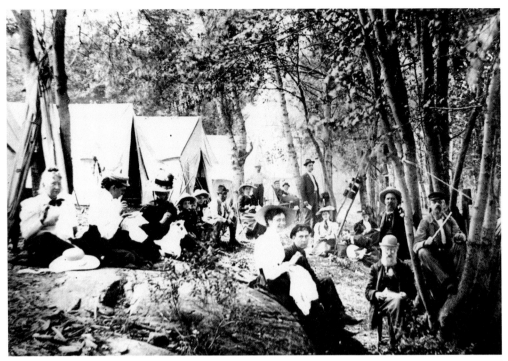

The Iron City Fishing Club is captured in action by photographer Frank E. Bingaman around 1894. (Courtesy of Carnegie Library of Pittsburgh.)

Copied from the *Pittsburgh Bulletin*, July 13, 1901, the July 4 bicycle races are shown at Schenley Park. (Courtesy of Carnegie Library of Pittsburgh.)

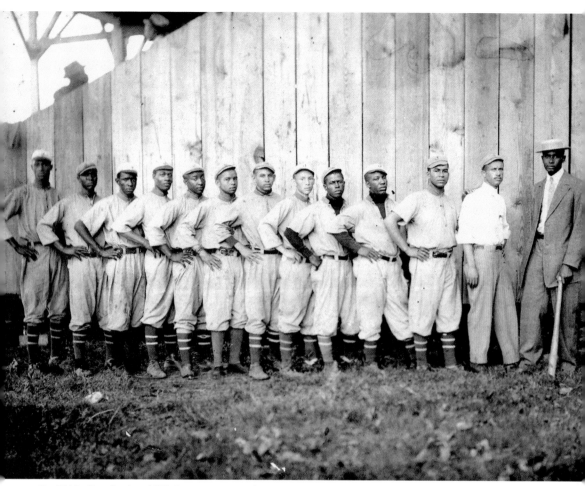

In 1910, Cumberland W. Posey organized a group of Homestead steelworkers into what was to be one of baseball's greatest clubs and gate attractions. In later years the Homestead Grays won eight out of nine Negro National League titles. Among its stars was the mighty home run hitter Josh Gibson. (Courtesy of Photo Antiquities Museum of Photographic History.).

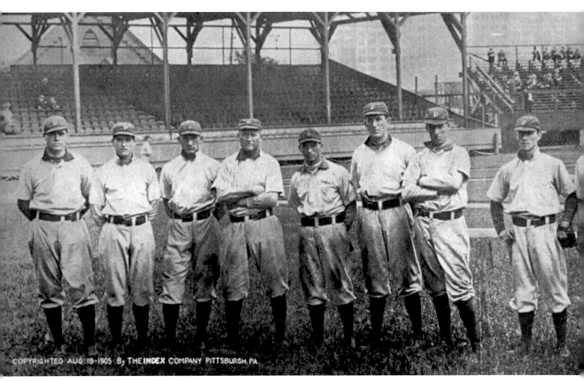

COPYRIGHTED AUG. 19-1905 By THE INDEX COMPANY PITTSBURGH PA.

The Pittsburgh Pirates take on the New York Giants during a game in Pittsburgh on Saturday, August 5, 1905. (Courtesy of Library of Congress, Prints and Photographic Division, Detroit

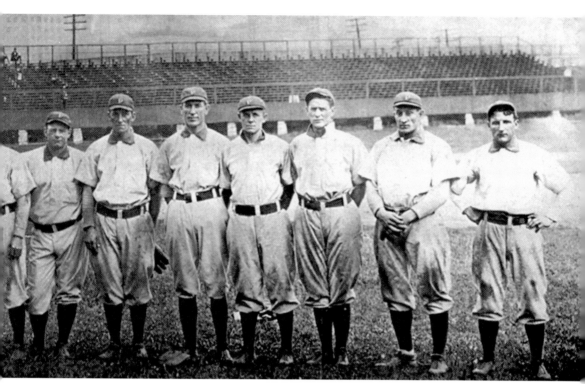

Publishing Company Collection.)

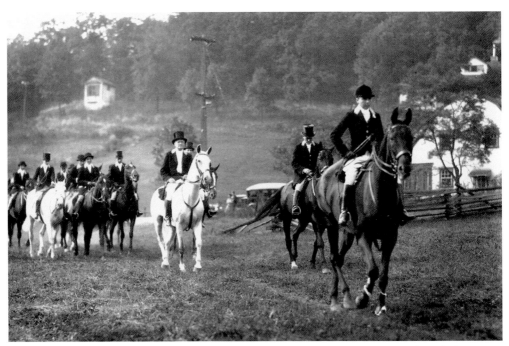

An unidentified rider leads a team on horseback for a day of foxhunting in an unidentified Western Pennsylvania location. (Courtesy of Photo Antiquities Museum of Photographic History.)

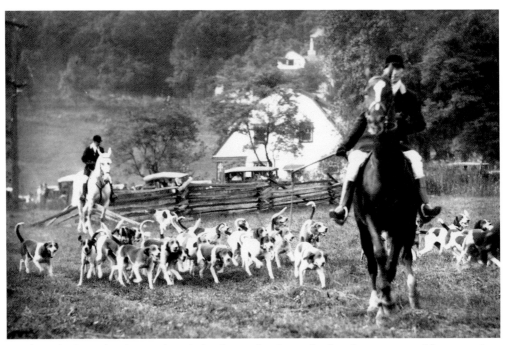

Send in the hounds! An unidentified rider on his horse leads a large group of hunting dogs chasing the scent of a fox during a hunt in this undated photograph. (Courtesy of Photo Antiquities Museum of Photographic History.)

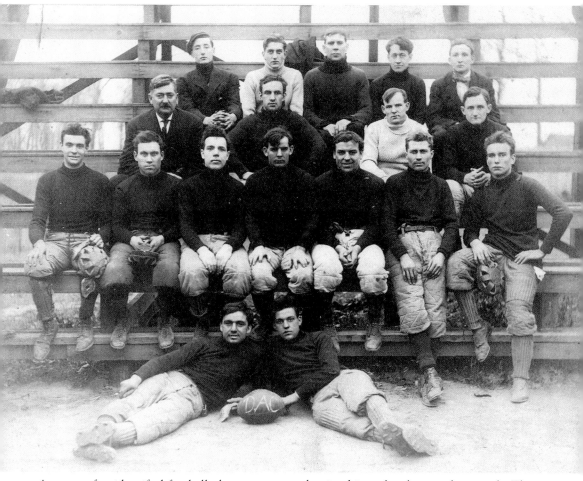

A group of unidentified football players pose together in this undated team photograph. The football in front shows "DAC." (Courtesy of Carnegie Library of Homestead.)

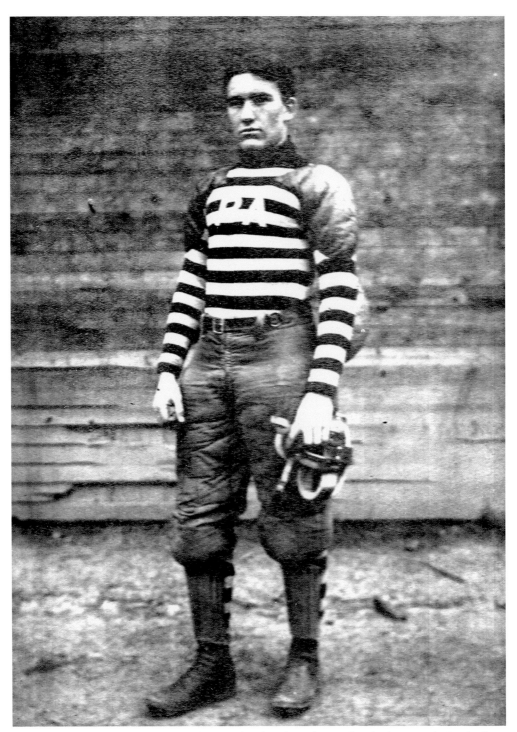

An unidentified athlete holds a helmet in his hand in this undated photograph. Back then, athletes did not wear all the protective gear they do today. (Courtesy of Photo Antiquities Museum of Photographic History.)

EARLY SPORTS MEMORIES

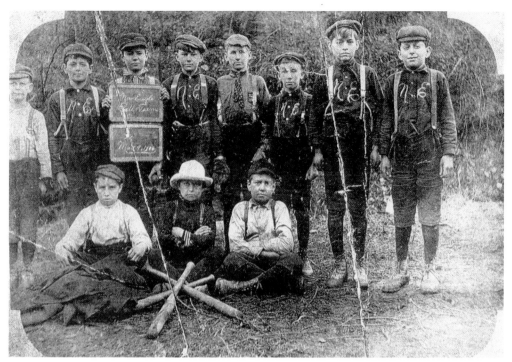

The New Eagle Ball Team poses for a photograph taken on March 9, 1906. Robert Barnes Brown of Mifflin Township, Allegheny County, stands fourth from the left in the second row among his unidentified teammates. (Courtesy of Elizabeth Banzen.)

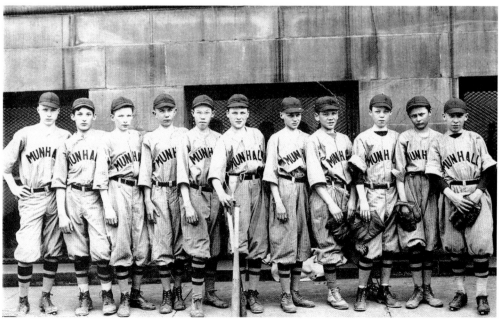

These young fellows from Munhall take time off the field to pose for this early 1900s photograph. (Courtesy of Carnegie Library of Homestead.)

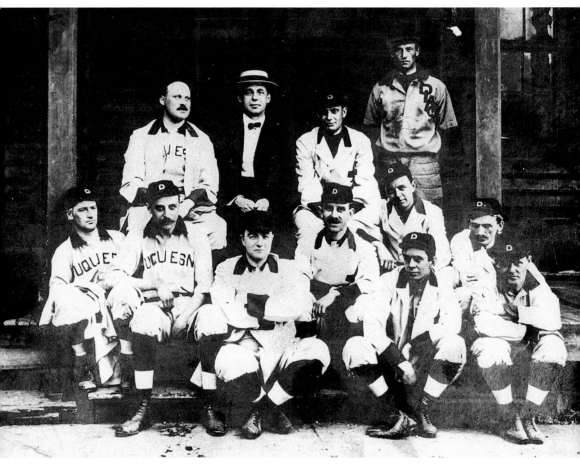

This 1906 photograph illustrates a time when the Duquesne Mill had a crack team and Homer D. Williams, superintendent of the Duquesne Steel Works of the Carnegie Steel Company (in second row with straw hat), was their chief booster. (Courtesy of Carnegie Library of Pittsburgh.)

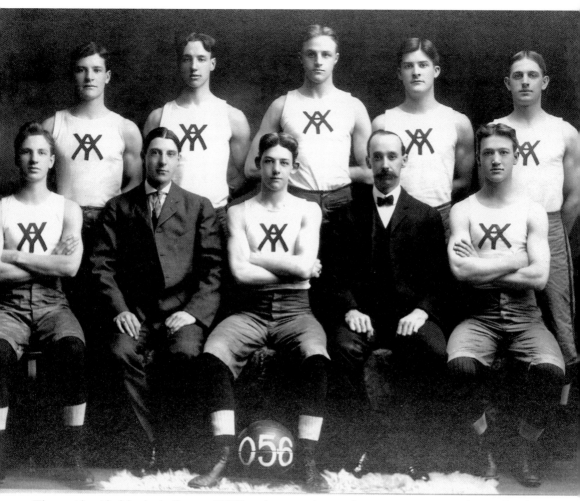

The unidentified basketball team "056" and its coaches strike a serious pose in this undated photograph. (Courtesy of Carnegie Library of Homestead.)

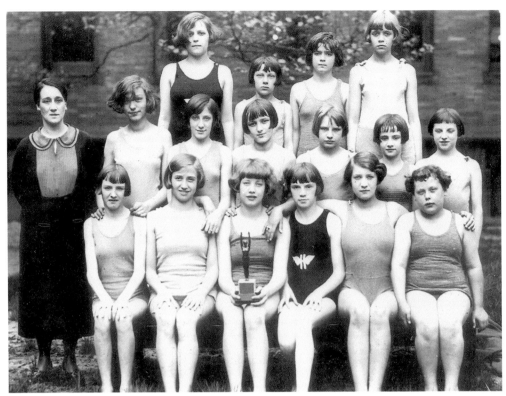

These unidentified members of a girl's swim team pose with a trophy in this undated photograph. (Courtesy of Carnegie Library of Homestead.)

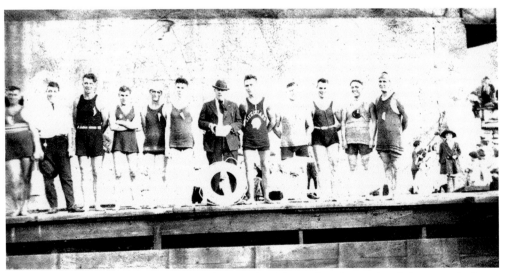

A group of unidentified swimmers pose along with a lifeguard in this undated photograph. Some swimmers spent time at local outdoor recreational facilities or practiced in the pools at any number of Andrew Carnegie's libraries in the Pittsburgh area. Many just enjoyed swimming in the Monongahela, Ohio, or Allegheny Rivers. (Courtesy of Carnegie Library of Homestead.)

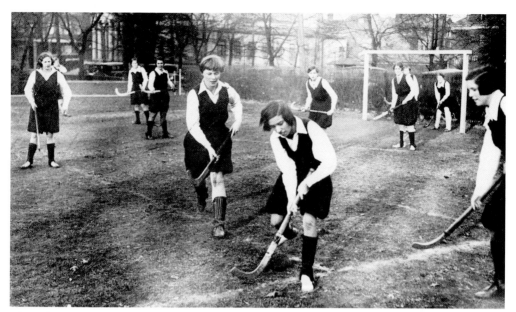

The girls at Winchester School find refreshing exercise in this favorite outdoor game, and the intergrade games are energetically played. This photograph originally appeared in the *Pittsburgh Sun-Telegraph*, Color-Gravure Section, on December 7, 1930. (Courtesy of Carnegie Library of Pittsburgh.)

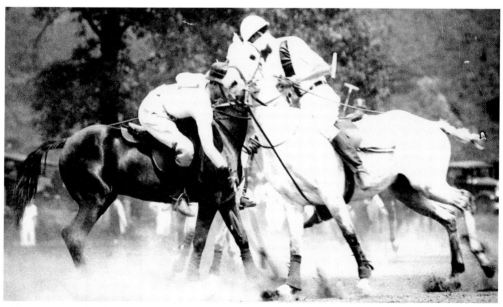

"Alert ponies, skillful riders combine to provide thrills in polo matches, which are becoming increasingly popular hereabouts," is the caption for this photograph entitled *Graceful Action*, which was featured in the *Pittsburgh Sun-Telegraph*, Color Gravure Section, on July 3, 1932. The picture shows Lieutenant Watson of the 107th Field Artillery team, number one, driving the ball goalward in a lively moment of a game with the South Park team. (Courtesy of Carnegie Library of Pittsburgh.)

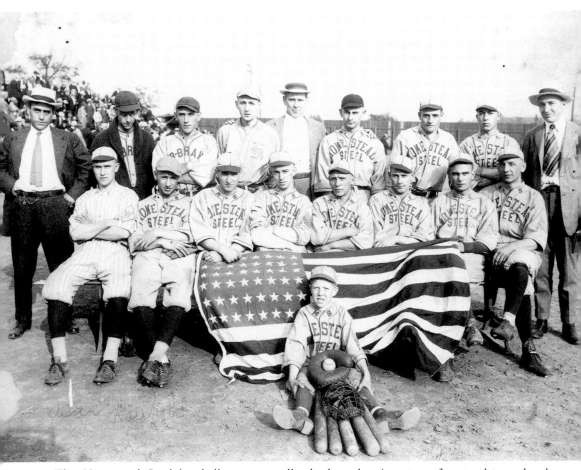

The Homestead Steel baseball team proudly displays the American flag in this undated photograph. (Courtesy of Carnegie Library of Homestead.)

2

FAMOUS FIRSTS

No other city of comparable size has had such success in sports than Pittsburgh. The city's professional baseball, football, and hockey teams have provided a number of well-known accomplishments, such as the Pirates' five World Series championships, the Steelers' five Super Bowl victories, and the Penguins' two Stanley Cup wins. Pittsburgh has also enjoyed championships from the University of Pittsburgh football team, the American Basketball Association's Pipers, and the Pittsburgh Triangles of World Team Tennis. In addition, the accomplishments and achievements of individual athletes have left a long-lasting impact, helping to build and shape the modern sports people have come to know today. The images that follow represent a select number of "famous firsts" in western Pennsylvania sports.

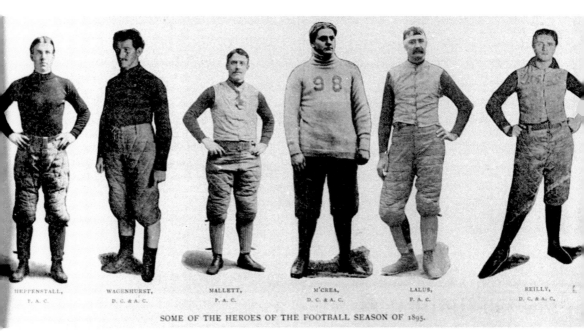

HEFFENSTALL,
P. A. C.

WAGENHURST,
D. C. & A. C.

MALLETT,
P. A. C.

M'CREA,
D. C. & A. C.

LALUS,
P. A. C.

REILLY,
D. C. & A. C.

SOME OF THE HEROES OF THE FOOTBALL SEASON OF 1895.

Western Pennsylvania is the birthplace of professional football. On November 12, 1892, the Allegheny Athletic Association paid All-American guard William "Pudge" Heffelfinger $500 to play against the Pittsburgh Athletic Club, making Heffelfinger the first paid player. This photograph shows "some of the heroes of the football season of 1895" in period uniforms. (Courtesy of Carnegie Library of Pittsburgh.)

FAMOUS FIRSTS

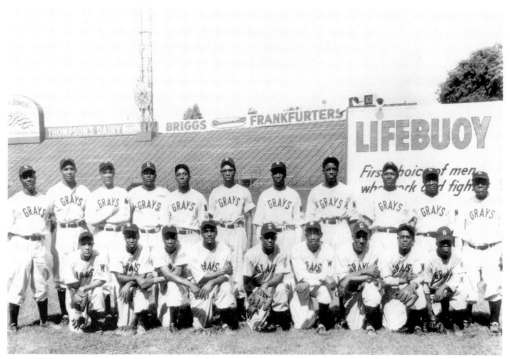

Pittsburgh's Negro League baseball teams the Homestead Grays (above) and the Pittsburgh Crawfords (below) had 12 national championships between them and provided 7 of the first 11 Negro League players inducted into the National Baseball Hall of Fame. (Courtesy of Photo Antiquities Museum of Photographic History.)

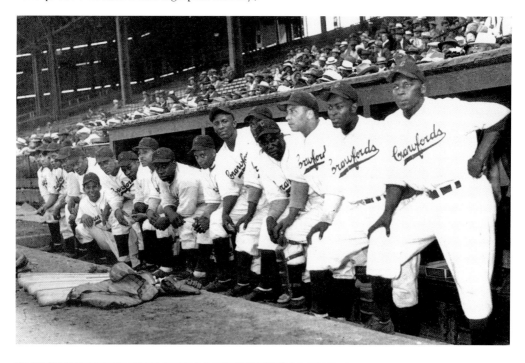

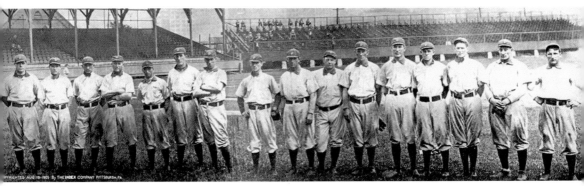

In October 1903, the Pittsburgh Pirates hosted four games of the first modern World Series, losing to the Boston Americans in the best of nine series. Pirates owner Barney Dreyfuss proposed the series as a way to increase revenues at the gate. This photograph shows the Pittsburgh Pirates, who played for the 1905 World Series pennant. (Courtesy of Library of Congress, Prints and Photographic Division.)

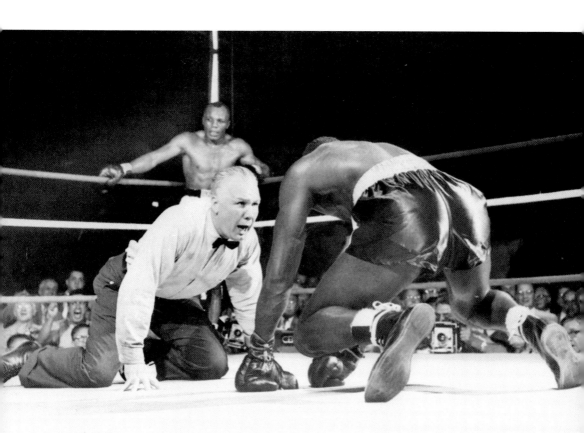

"Nearly 30,000 were at Forbes Field Wednesday night, July 18, 1951, to see Pittsburgh's first heavyweight title fight. In the seventh round, Jersey Joe Walcott, 37-year-old father of six, delivered a 'crunching half hook and half upper cut.' The champion, Ezzard Charles, a Cincinnatian managed by a Pittsburgher, Jake Mintz, dropped to the canvas," wrote the *Post-Gazette*. This national prize-winning picture was taken by James G. Klingensmith of the *Post-Gazette*. (Courtesy of Carnegie Library of Pittsburgh.)

The Ice Capades was founded in Pittsburgh in 1940 with an $85,000 investment by local entertainment wizard John H. Harris. The franchise was sold in 1963 for $5.5 million. (Courtesy of Lisa A. Alzo.)

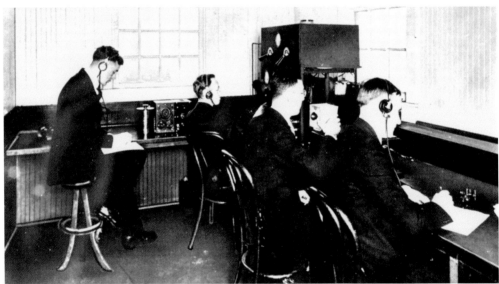

KDKA Radio broadcast the first radio play-by-play of a baseball game on August 5, 1921. Dr. Frank Conrad, assistant chief engineer of Westinghouse Electric, first constructed a transmitter and installed it in a garage near his home in Wilkinsburg in 1916. The station was licensed as 8XK. At 6:00 p.m. on November 2, 1920, 8KX became KDKA Radio and began broadcasting the returns for the Harding-Cox presidential election at 100 watts from a makeshift shack atop one of the Westinghouse manufacturing buildings in East Pittsburgh. (Courtesy of Carnegie Library of Pittsburgh.)

FAMOUS FIRSTS

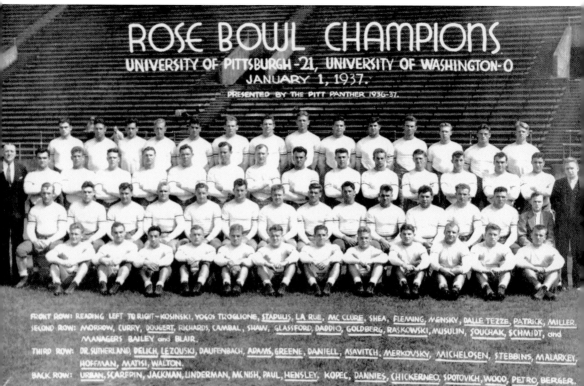

The University of Pittsburgh scored 21 points and the University of Washington scored zero points at the Rose Bowl. Pictured here, most identified only by their last names, from left to right are (first row) Kosinski, Yogos, Troglione, Stadulis, La Rue, McClure, Shea, Fleming, Mensky, Dalle Tezze, Patrick, and Miller; (second row) Morrow, Curry, Dougert, Richards, Cambal, Shaw, Glassford, Daddio, Goldberg, Raskowski, Musulin, Souchak, Schmidt, and managers Bailey and Blair; (third row) coach Sutherland, Delich, Lezouski, Daufenbach, Adams, Greene, Daniell, Asavitch, Merkovsky, Michelosen, Stebbins, Malarkey, Hoffman, Matisi, and Walton; (fourth row) Urban, Scarfpin, Jackman, Underman, McNish, Paul, Hensley, Kopec, Dannies, Chickerneo, Spotovich, Wood, Petro, and Berger. (Courtesy of University of Pittsburgh Archives, Archives Service Center, University of Pittsburgh.)

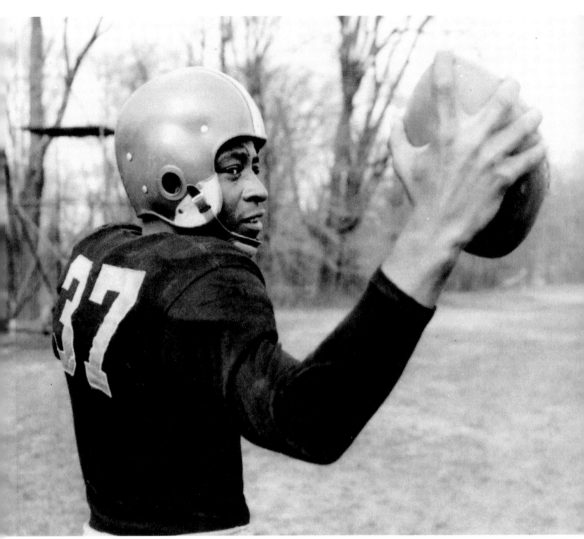

New Kensington's Willie Lawrence Thrower (1930–2002) became the first African American to play quarterback in the modern NFL when he played for the Chicago Bears on October 18, 1953. Only 5 feet 11 inches tall, Thrower lacked prototype size, but he had a rifle arm. He led Michigan State University to the national college championship in 1952. (Courtesy of Michigan State University Sports Information and the Willie Thrower Foundation.)

3

HOMETOWN HEROES

Western Pennsylvania boasts a significant number of athletes who have achieved national and international recognition for achievements both on and off the court. Famous faces include Carnegie's Honus Wagner and Latrobe native Arnold Palmer; star quarterbacks Jim Kelly, Dan Marino, Joe Montana, Joe Namath, Johnny Unitas, and George Blanda; and favorite "adopted sons" such as Roberto Clemente and Mario Lemieux, among many others. This chapter showcases a few of the most recognizable hometown heroes.

This photograph shows a young Honus Wagner, a native of Carnegie and legendary player and coach for the Pirates, who is considered by many to be the greatest shortstop in baseball history. (Courtesy of Photo Antiquities Museum of Photographic History.)

One of Pittsburgh's favorite sons, baseball legend Honus Wagner, sits atop a trunk showing the label "Pittsburgh Baseball Club" in this c. 1900 photograph. Wagner made his major-league debut on July 19, 1897, and played for the Louisville Colonels from 1897 to 1899 and the Pittsburgh Pirates from 1900 to 1917. (Courtesy of Photo Antiquities Museum of Photographic History.)

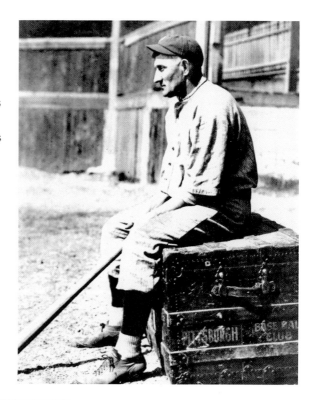

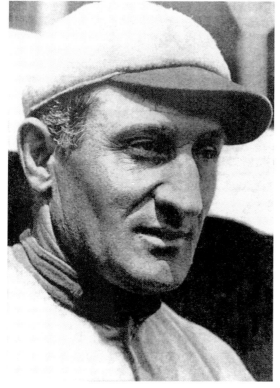

Honus Wagner was elected as a player to the Baseball Hall of Fame by baseball writers in 1936, with 215 votes on 226 ballots, and was one of the hall's five original inductees. (Courtesy of Leslie Wagner Blair.)

Honus Wagner demonstrated a rare combination of offensive and defensive excellence throughout a 21-year career. His biography in the Baseball Hall of Fame reads, "Despite his awkward appearance—stocky, barrel-chested and bow-legged—the longtime Pirates shortstop broke into the big leagues by hitting .344 in 1897 with Louisville, the first of 17 consecutive seasons of hitting over .300, including eight as the National League batting champion." (Courtesy of Photo Antiquities Museum of Photographic History.)

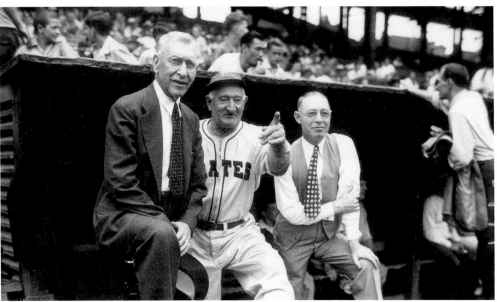

Wagner retired from the Pirates in 1917 with more runs scored, more hits, and more stolen bases than any other player in the history of the National League. Wagner served as manager of the Pirates briefly in 1917, but resigned the position after only five games. Wagner returned to the Pirates as a coach, most notably as a hitting instructor from 1933 to 1952. (Courtesy of Photo Antiquities Museum of Photographic History.)

This is a card drawing of Pittsburgh Pirate's Tommy Leach printed by the Baseball and Athletic Picture Department, around 1911. Leach was a center fielder and third baseman in major-league baseball in the late-19th and early-20th centuries, playing 19 big-league seasons. He also participated in the first modern World Series in 1903 with the Pittsburgh Pirates, hitting four triples to set a record that still stands. (Courtesy of Photo Antiquities Museum of Photographic History.)

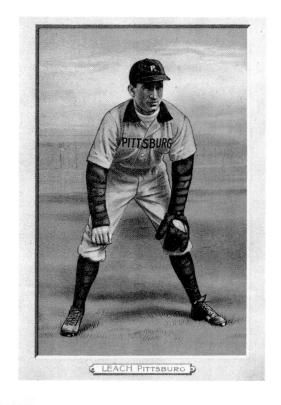

LEACH PITTSBURG

N.º 3
PROMINENT BASE BALL PLAYERS & ATHLETES
ORDER BY NUMBER ONLY

1 M. Brown, Chicago Nat'l	26 McGraw, New York Nat'l	51 Jem Driscoll
2 Bergen, Brooklyn	27 Mathewson, N. Y. Nat'l	52 Abe Attell
3 Leach, Pittsburg	28 H. McIntyre, Brooklyn	53 Ad. Wolgast
4 Bresnahan, St. Louis Nat'l	29 McConnell, Boston Amer.	54 Johnny Coulon
5 Crawford, Detroit	30 Mullin, Detroit	55 James Jeffries
6 Chase, New York American	31 Magee, Philadelphia Nat'l	56 Jack (Twin) Sullivan
7 Camnitz, Pittsburg	32 Overall, Chicago National	57 Battling Nelson
8 Clarke, Pittsburg	33 Pfeister, Chicago National	58 Packey McFarland
9 Cobb, Detroit	34 Rucker, Brooklyn	59 Tommy Murphy
10 Devlin, New York Nat'l	35 Tinker, Chicago National	60 Owen Moran
11 Dahlen, Brooklyn	36 Speaker, Boston American	61 Johnny Marto
12 Donovan, Detroit	37 Sallee, St. Louis National	62 Jimmie Gardner
13 Doyle, New York National	38 Stahl, Boston American	63 Harry Lewis
14 Dooin, Philadelphia Nat'l	39 Waddell, St. Louis Amer.	64 Wm. Papke
15 Elberfeld, Washington	40 Willis, St. Louis National	65 Sam Langford
16 Evers, Chicago National	41 Wiltse, New York National	66 Knock-out Brown
17 Griffith, Cincinnati	42 Young, Cleveland	67 Stanley Ketchel
18 Jennings, Detroit	43 Out at Third	68 Joe Jeannette
19 Joss, Cleveland	44 Trying to Catch Him Nap'g	69 Leach Cross
20 Jordan, Brooklyn	45 Jordan and Herzog at First	70 Phil. McGovern
21 Kleinow, New York Amer.	46 Safe at Third	71 Battling Hurley
22 Krause, Philadelphia Amer.	47 Frank Chance at Bat	72 Honey Mellody
23 Lajoie, Cleveland	48 Jack Murray at Bat	73 Al Kaufman
24 Mitchell, Cincinnati	49 A Close Play at Second	74 Willie Lewis
25 M. McIntyre, Detroit	50 Chief Myers at Bat	75 Philadelphia Jack O'Brien

Any one of the above named pictures given in exchange for 10 Coupons taken from Turkey Red Cigarettes or 25 Coupons from either Old Mill or Fez Cigarettes. Send coupons by Mail or express. charges prepaid to

BASE BALL AND ATHLETE PICTURE DEPT.
DRAWER S. JERSEY CITY, N.J.
THIS OFFER EXPIRES JUNE 30-1911.

Shown is the back side of the c. 1911 card of Tommy Leach (Pittsburg) printed by the Baseball and Athletic Picture Department. (Courtesy of Photo Antiquities Museum of Photographic History.)

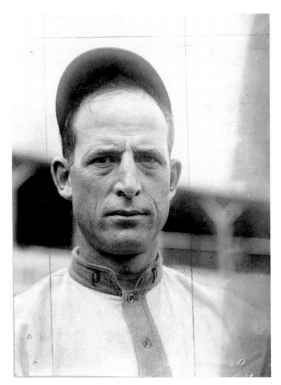

Fred Clifford "Cap" Clarke was a player-manager for the Pittsburgh Pirates baseball team from 1900 to 1915. In 1903, he led the league in doubles and slugging average while piloting the Pirates to an appearance in the first modern World Series. A full-time player-manager in 16 of his 19 seasons at the helm, Clarke led his clubs to 14 first-place division finishes. (Courtesy of Library of Congress, Prints and Photographic Division, Detroit Publishing Company Collection.)

J. E. "Sunny" Kesner, quarterback, carries the ball in this undated photograph. He played for Carnegie Tech in 1913, 1914, 1915, and 1916 and then served with the U.S. military in Company A, 15th Engineers in France. (Courtesy of Carnegie Library of Pittsburgh.)

HOMETOWN HEROES

George "Ganzy" Benedict was an all-district football and basketball player at Duquesne University during the 1929–1930 season and went on to play semiprofessional basketball and baseball for teams in the city of Duquesne. He was inducted into the Duquesne University Sports Hall of Fame in 1968. (Courtesy of the Benedict family.)

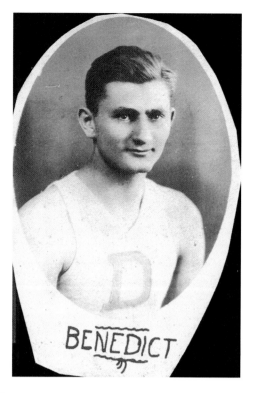

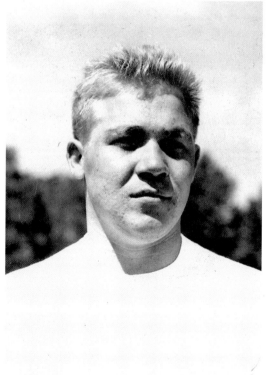

Many local athletes who excelled at high school sports went on to play for college teams. Joseph Figlar, seen in this undated photograph, was a football standout at Duquesne High School before going on to play for Case Western Reserve University and later went on to a career as a high school football and wrestling coach at St. Edward's High School in Lakewood, Ohio. Figlar, like many Slovak men of the second generation, found his ticket to higher education through sports, earning a football scholarship. (Courtesy of Lisa A. Alzo.)

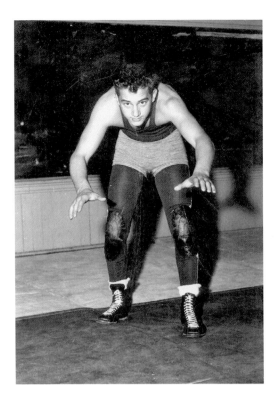

Munhall High School wrestler Joe Dorcak poses in this 1956 photograph. Dorcak won a decision in the 145-pound class in the Section Two Regional semifinal match in Latrobe. (Courtesy of Joe Dorcak.)

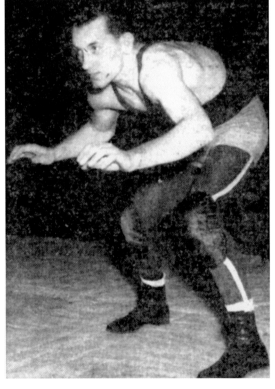

Paul Eckley was a top wrestler for Munhall High School in Munhall in the 165-pound class. This photograph was taken in 1956 when he was a favorite to win the Western Pennsylvania Interscholastic Athletic League championship. (Courtesy of Joe Dorcak.)

Joe Sivak, who played football for Apollo High School and went on to play for New York University, is seen in this c. 1938 photograph. A New York newspaper had the following to say about him: "For a little fellow, he certainly hits hard on his blocks and is a ball hawk on receiving and intercepting passes." (Courtesy of the Sivak family.)

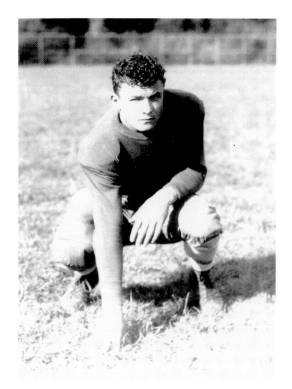

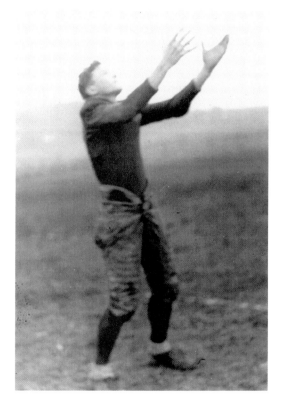

This 1932 photograph captures Apollo High School football player Joseph Sivak waiting to catch the ball. (Courtesy of the Sivak family.)

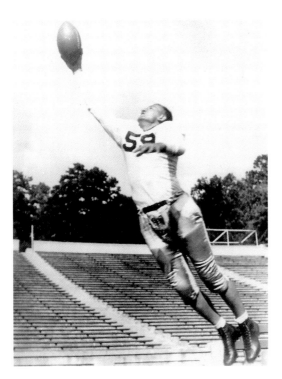

Andy Bershak, of Clairton, a standout right end at North Carolina goes up in mid-air for the football in this 1930s photograph. (Courtesy of the Sivak family.)

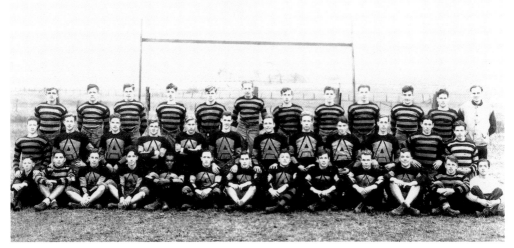

This photograph shows the Apollo Tigers football team in "the glory days" of 1932. The team posted an 8-3 record. From left to right are (first row) Russ McGuire, Grick Long, Bill Fryar, George Shank, Essie Davis, Russ Shank, Hen Hockstine, Joe Sivak, Lyle Ridenour, Don Schockey, Bun Morrow, Ned Mangus, and Bud McCain (manager); (second row) Dominic Vittone, Logan Bodenhorn, Chuck Forbes, Les Uptegraph, Giarth Newton, John Clare, Dale Walker, Kenny Johnson, Shorty Richards, Art Fulton, Benny Wiseband, and Bill "Fats" Miller; (third row) Leroy Campbell, George Gess, Perry Walker, Franklin Wyble, Kenny Newton, Bill Jasper, Chuck Beecher, Gernie Moorhead, Bill Speer, Leroy Talmadge, William Miller, and Chuck Buzzard (coach). (Courtesy of the Sivak family.)

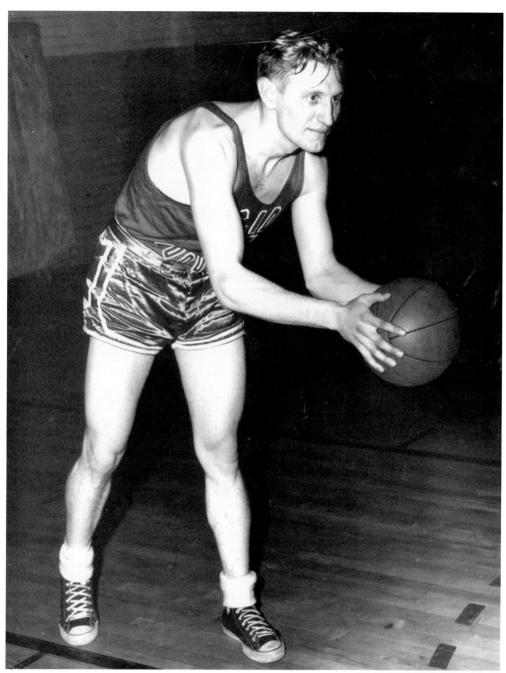

Crack forward Johnny Alzo, a 1943 Duquesne High School basketball standout, gets ready to shoot a foul shot in this undated photograph snapped during a Duquesne Congress of Industrial Organizations (CIO) basketball game. Alzo played for several local semiprofessional basketball teams in the 1940s and 1950s and was dubbed by the local press as "one of the most promising players in the district" and by his former high school coach as "One of the All-Time Best." (Courtesy of Lisa A. Alzo.)

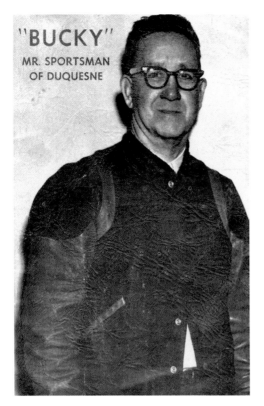

"BUCKY"

MR. SPORTSMAN
OF DUQUESNE

The souvenir booklet is from September 13, 1969, for the testimonial dinner honoring Orrin "Bucky" Sable as "Mr. Sportsman of Duquesne." Bucky was honored for his varied contributions to the sporting community of Duquesne he served so well as a player, coach, manager, and spectator. (Courtesy of John Alzo.)

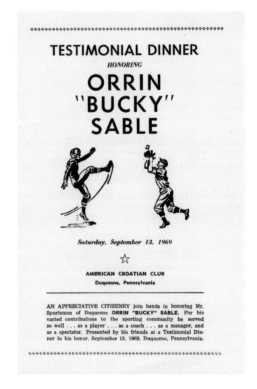

TESTIMONIAL DINNER
HONORING

ORRIN
"BUCKY"
SABLE

Saturday, September 13, 1969

☆

AMERICAN CROATIAN CLUB
Duquesne, Pennsylvania

AN APPRECIATIVE CITIZENRY join hands in honoring Mr. Sportsman of Duquesne ORRIN "BUCKY" SABLE. For his varied contributions to the sporting community he served so well . . . as a player . . . as a coach . . . as a manager, and as a spectator. Presented by his friends at a Testimonial Dinner in his honor. September 13, 1969, Duquesne, Pennsylvania.

HOMETOWN HEROES

Billy Conn was born on October 8, 1917, in Pittsburgh. Conn never fought as an amateur. He was managed by Johnny Ray, who fought as a lightweight and trained with International Boxing Hall of Fame inductee Harry Greb. Conn made his professional debut at age 16 when he lost a decision to 21-year-old Dick Woodward. Most of Conn's early fights were against older, more experienced opponents. Conn began his career at welterweight and fought up to heavyweight. By the age of 21 Conn had defeated nine present or former world champions. Almost one-third of his fights were against titleholders. Although often outweighed, Conn never lost to a heavyweight, with the exception of Joe Louis. (Courtesy of Tim Conn.)

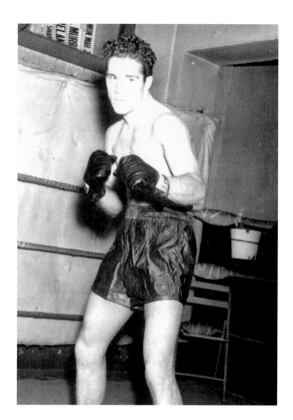

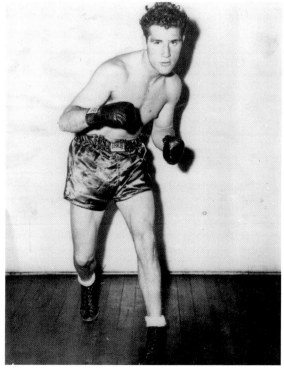

Conn gained national attention with his upset victories over middleweight champion Fred Apostoli. At the time, Apostoli was regarded as the best pound-for-pound fighter in the world. Conn beat him in his New York debut at Madison Square Garden with a 10-round decision and won again in 15 rounds just five weeks later. They were two of the most thrilling fights in middleweight history. Conn considered his fights with Apostoli the toughest of his career. (Courtesy of Tim Conn.)

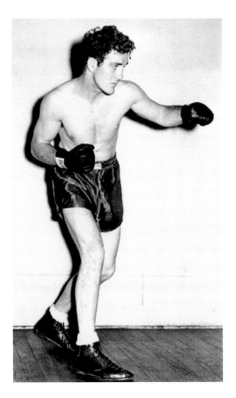

Billy Conn won the world light heavyweight title from Melio Bettina on July 13, 1939. He later gave up the title to campaign as a heavyweight. (Courtesy of Tim Conn.)

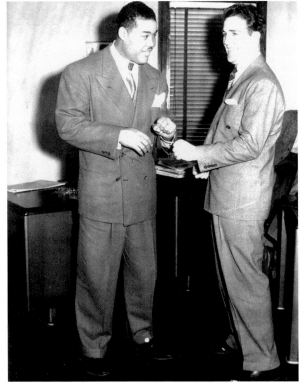

Conn (right), seen here in this photograph with Joe Louis, was generally regarded as the world's most handsome fighter and starred in a movie for Republic Pictures called *The Pittsburgh Kid* in 1941. But he turned down a career in Hollywood, including a role in *On the Waterfront* to live in Pittsburgh with his wife, Mary Louise. At the age of 72, Conn once again made national headlines by interrupting a convenience store robber in Pittsburgh. Conn decked the gunman, who was later arrested. Conn died in 1993 at the age of 75. (Courtesy of Photo Antiquities Museum of Photographic History.)

Roberto Clemente (1934–1972), a native of Puerto Rico, was one of the most popular players in Pittsburgh Pirate baseball history. He was drafted by the Pirates in 1954 and played for them from 1955 until his untimely death in a tragic plane crash on December 31, 1972, off the coast of Puerto Rico, while en route to transport medical, food, and clothing supplies to earthquake-stricken Nicaragua. Clemente was elected to the National Baseball Hall of Fame posthumously in 1973. He was this first Hispanic player to be inducted, and the only exception to the mandatory five-year post-retirement waiting period, which was instituted in 1954. (Courtesy of Photo Antiquities Museum of Photographic History.)

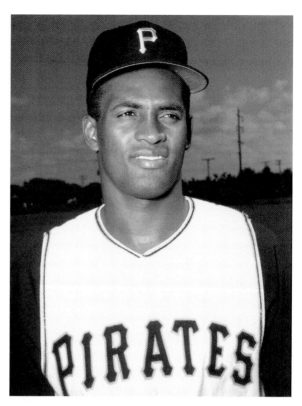

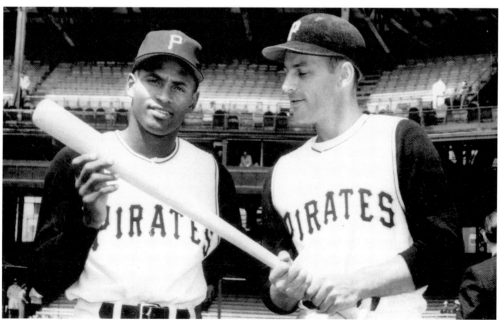

A young Clemente (left) and Pirates shortstop Dick Groat examine a bat. Groat, a Pittsburgh native, also excelled in basketball at Duke University. (Courtesy of Photo Antiquities Museum of Photographic History.)

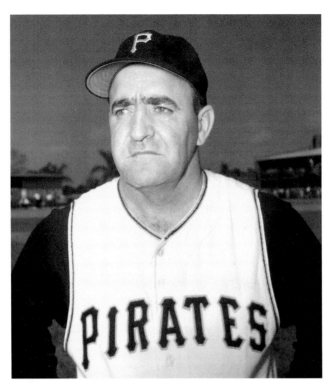

Daniel Edward (Danny) Murtaugh was born on October 8, 1917, in Chester. He played major-league baseball as a second baseman for nine seasons (1941 to 1943, and 1946 to 1951) with the Philadelphia Phillies, Boston Braves, and Pittsburgh Pirates. Joining the Pirates in 1948, he began his long association with Pittsburgh as a player, coach, and manager, a tenure that included five first-place finishes and two World Series titles. Murtaugh died on December 2, 1976, in Chester. (Courtesy of Photo Antiquities Museum of Photographic History.)

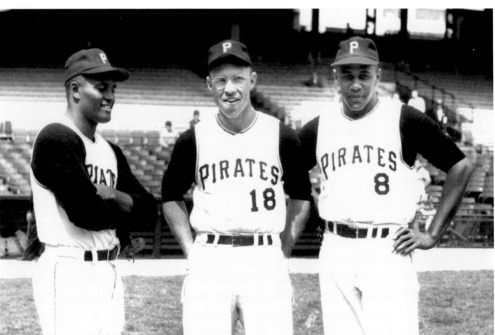

From left to right, Roberto Clemente, Bill Virdon, and Willie Stargell of the Pittsburgh Pirates pose for this 1960s photograph at Three Rivers Stadium in Pittsburgh. (Courtesy of Photo Antiquities Museum of Photographic History.)

Arthur J. (Art) Rooney (1901–1988) was born in Coultersville, east of Pittsburgh. He is quoted as saying, "My mother's people were all coal miners and my father's people were all steel workers," and while growing up his lived with his family on the second floor of his father's bar, Dan Rooney's saloon in Pittsburgh. Rooney made sports history when he purchased his Pittsburgh Steelers football franchise in 1932. Rooney has received many honors since his death in 1988. The statue in this photograph was originally located outside of gate D at Three Rivers Stadium, and now sits outside of Heinz Field, the Steelers' new home. The street in front of Heinz Field was also named Art Rooney Avenue in his honor. (Courtesy of Daniel J. Burns.)

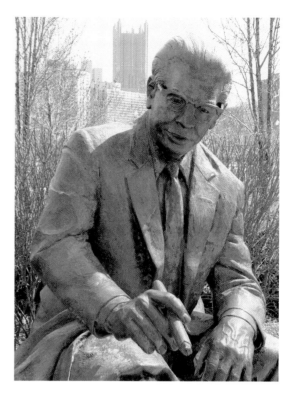

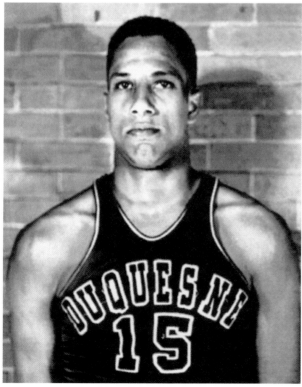

While playing for Pittsburgh's Westinghouse High School, Chuck Cooper twice won all-city basketball honors. At Duquesne University, he was an All-American, played on two National Invitational Tournaments, and was the Dukes' captain his senior year. The 1950–1951 NBA season marked the first appearance of black players in the league. Cooper became the first black player to be drafted when he was chosen by Boston; Nat "Sweetwater" Clifton became the first to sign an NBA contract when he signed with New York; and Earl Lloyd became the first to play in an NBA regular-season game because the schedule had his Washington team opening one day before the others. (Courtesy of Duquesne University.)

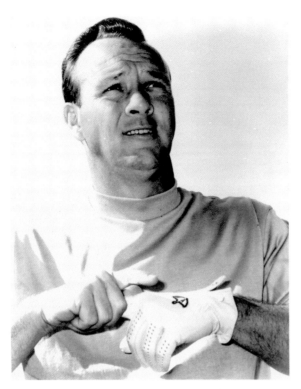

A native of Latrobe, Arnold Palmer won 60 tour events and seven majors (four Masters, two British Opens, and one U.S. Open). Huge galleries followed him at tournaments for nearly three decades. Palmer's legion of fans became known as "Arnie's Army." (Courtesy of Arnold Palmer Enterprises.)

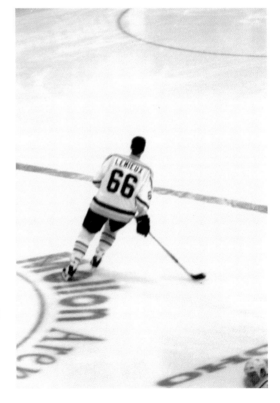

Mario Lemieux, who is considered one of the greatest players in NHL history, joined the Pittsburgh Penguins in 1984. Lemieux captained both Penguins Stanley Cup champion teams in 1991 and 1992. His career highlights include three Most Valuable Player (MVP) awards, six league-scoring titles, Rookie of the Year (1984), and twice was voted MVP of the playoffs. Although a native of Montreal, he chose to remain in Pittsburgh after his retirement. Lemieux received a special exemption and was inducted into the Hockey Hall of Fame in 1997. In late 2000, Lemieux made a comeback and played until 2006. This photograph shows Lemieux's return to the ice. (Courtesy of Library and Archives Division, Historical Society of Western Pennsylvania, Pittsburgh.)

HOMETOWN HEROES

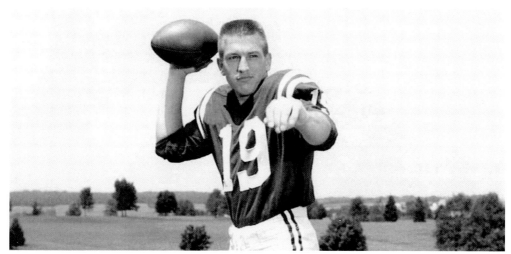

John Constantine Unitas was born on May 7, 1933, in Pittsburgh. A six-foot-one-inch quarterback, he played college ball for Louisville. He made a solid reputation for himself while at Louisville that got him into the ninth slot for the Pittsburgh Steelers draft of 1955. Unitas was eventually told the club could not use him; they had too many quarterbacks. The Steelers had waited so long to let him go that it was too late for a chance of being drafted anywhere else. But then, in February 1956, the Baltimore Colts signed him, and he played for them until 1972, amassing numerous records and the nicknames "the Golden Arm" and "Johnny U." Unitas retired in 1973 after one year with the San Diego Chargers, and was elected into the Pro Football Hall of Fame in 1979. He has been named "the Greatest Quarterback of all Time," and the quarterback of the "All-Century Team." Unitas died on September 11, 2002, at the age of 69. (Courtesy of Unitas Management Corporation.)

George Frederick Blanda was born September 17, 1927, in Youngwood and played football as a quarterback-kicker. He played college ball at Kentucky and then went on to play for the following professional teams: 1949 Chicago Bears, 1950 Baltimore Colts, 1950–1958 Chicago Bears, 1960–1966 Houston Oilers, and 1967–1975 Oakland Raiders. Blanda is famous for last-minute heroics in five straight 1970 games and played the game until the age of 48. He was elected into the Professional Football Hall of Fame in 1981. (Courtesy of Youngwood High School.)

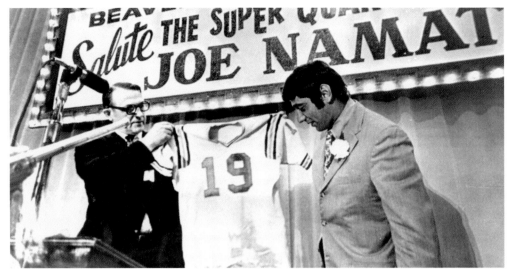

Joseph William (Joe) Namath played for Beaver Falls High School, then for the University of Alabama, before a professional career with the New York Jets. His flair both on and off the field earned him the nickname "Broadway Joe." Elected to the Pro Football Hall of Fame in 1985, Namath is best remembered for guaranteeing the upstart Jets would defeat the heavily favored Baltimore Colts in Super Bowl III in 1969. His prediction came true, and the Jets' 16-7 victory gave the young American Football League instant credibility. (Courtesy of Library and Archives Division, Historical Society of Western Pennsylvania, Pittsburgh.)

James Edward (Jim) Kelly was a prep standout at East Brady High School where he won all-state honors after passing for 3,915 yards and 44 touchdowns in his career. He also starred on defense of his East Brady team and was heavily recruited as a linebacker by Penn State's Joe Paterno. Kelly went on to play quarterback for the University of Miami, and then for the Houston Gamblers of the USFL and the Buffalo Bills of the National Football League. He was inducted into the Pro Football Hall of Fame in 2002. (Courtesy of Jim Kelly.)

HOMETOWN HEROES

A native of Oakland, Daniel Constantine (Dan) Marino Jr. was a standout quarterback and pitcher-shortstop at Pittsburgh's Central Catholic High School. Marino went on to play quarterback for the University of Pittsburgh Panthers and for the Miami Dolphins in the NFL, where he earned Rookie of the Year honors in 1983. He was inducted into the Pro Football Hall of Fame in 2005. (Courtesy of Mike Gallagher.)

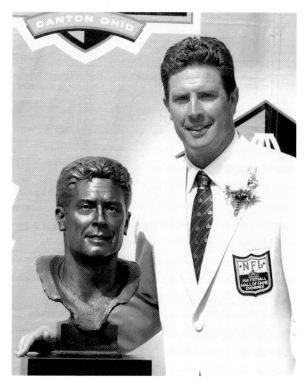

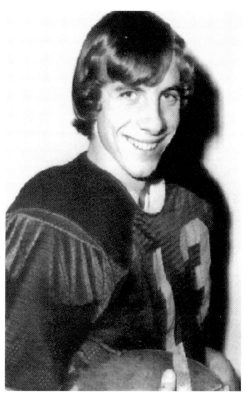

Joseph Clifford (Joe) Montana, a native of Monongahela, excelled in both basketball and football at Ringgold High School and then went on to earn his reputation as the "Comeback Kid" as quarterback of Notre Dame's 1977 national championship team. He was drafted into the NFL in 1979 and led the San Francisco 49ers to four Super Bowl titles in the 1980s. Twice named the NFL's MVP, he is also the only three-time Super Bowl MVP. He is a member of the class of 2000 of the Pro Football Hall of Fame. (Courtesy of Ringgold High School.)

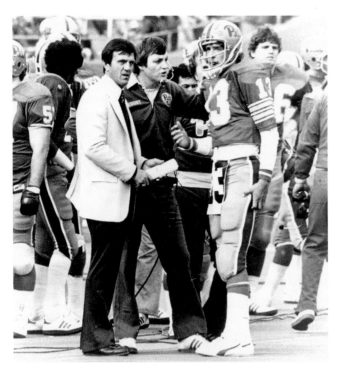

In this photograph, Pitt coaches Jackie Sherrill and Joe Pendry confer with quarterback Dan Marino. Marino led Pitt to four consecutive top 10 Associated Press poll finishes and four bowl game appearances. He continued his football success with the Miami Dolphins as quarterback. He retired from the Dolphins in 2000 after a 17-year career. (Courtesy of University of Pittsburgh Archives, Archives Service Center, University of Pittsburgh.)

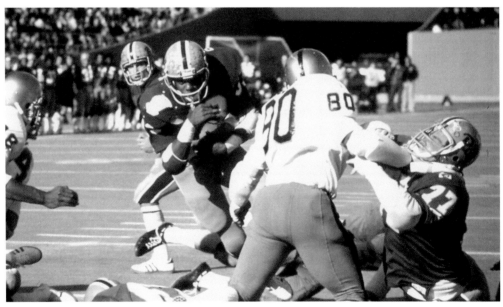

Anthony Drew (Tony) Dorsett was born in Rochester and lived in Hopewell Township. He was a star at Hopewell High School and stayed in western Pennsylvania to play for the University of Pittsburgh. In 1976, Dorsett won the Heisman Trophy, the Maxwell Award, and the Walter Camp Award. He also led Pitt to a national title. Dorsett was a four-time All-American and finished his college career with 6,082 rushing yards, an NCAA record that stood for 22 years. (Courtesy University of Pittsburgh.)

HOMETOWN HEROES

4

FOR THE LOVE

OF THE GAME

From the young men who first touched a basketball on the courts in one of Andrew Carnegie's libraries in towns like Braddock, Duquesne, or Homestead; to those who played baseball or football in neighborhood sandlots, schoolyards, and playgrounds across western Pennsylvania; or those enjoyed bowling, golf, or swimming, there are countless numbers of unsung heroes and untold stories of athletes and teams who played not for money or fame but because they enjoyed the athletic challenge and the thrill of competition. The following pages contain images that pay tribute to all of those men and women who played "for the love of the game."

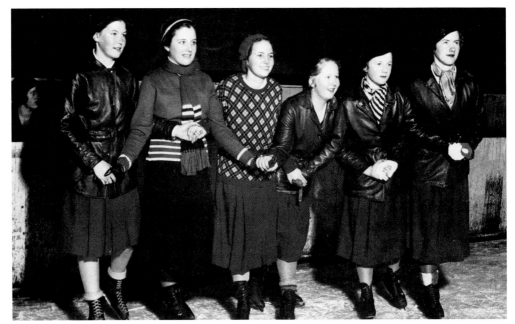

"Pittsburgh's Younger Society Girls Skate," was the title of the caption for this photograph that appeared in the *Pittsburgh Sun-Telegraph*, Color-Gravure Section, on January 17, 1932, with the caption "These young girls show grace and ability on the ice at Duquesne Gardens. Left to right: Marguerite Merrick, Louise McKinney, Carolyn Huston, Jessie Petty, Barbara Taylor and Katherine Eton." (Courtesy of Carnegie Library of Pittsburgh.)

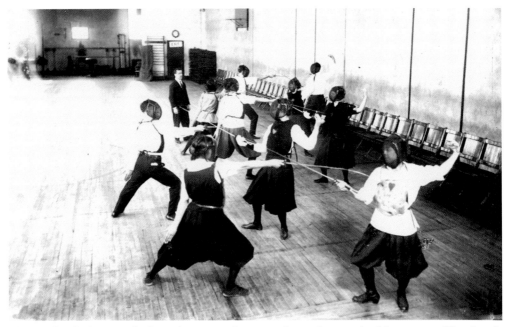

This undated photograph shows lessons in fencing taking place at the University of Pittsburgh gymnasium. (Courtesy of Carnegie Library of Pittsburgh.)

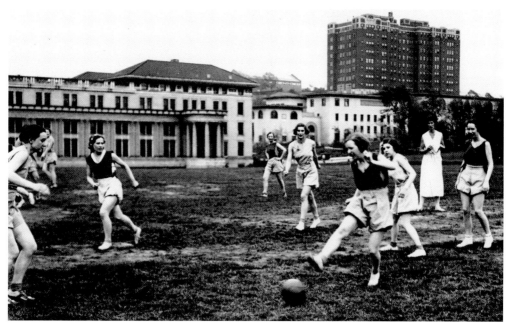

This photograph titled *Boot it Lassie* appeared in the *Pittsburgh Sun Telegraph* on May 22, 1932, with the caption "There's been many a lively soccer tilt this sprint on the campus at Carnegie Tech between girls' teams from Margaret Morrison School. This action was photographed in a recent match between the Sophs and Freshies." (Courtesy of Carnegie Library of Pittsburgh.)

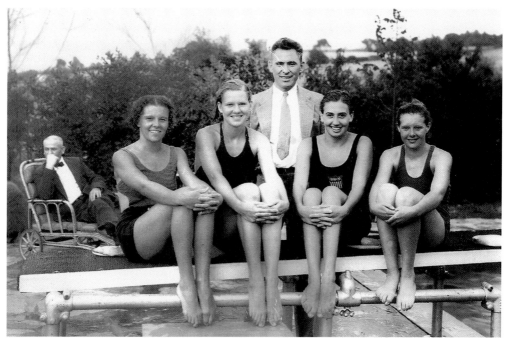

This undated photograph shows four unidentified young swimmers from Homestead or Munhall with their coach. (Courtesy of Carnegie Library of Homestead.)

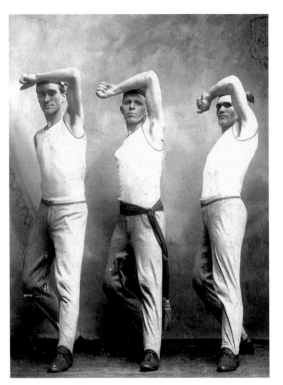

Michael Sinchak (center) and John Hromey (right) posed with a third unidentified male for a photograph taken during the 1930s at the Slovak Catholic Sokol in Monessen. The Slovak Gymnastics Sokol of the U.S.A. began in Bridgeport, Connecticut, in 1896. (Courtesy of Regina Feryok.)

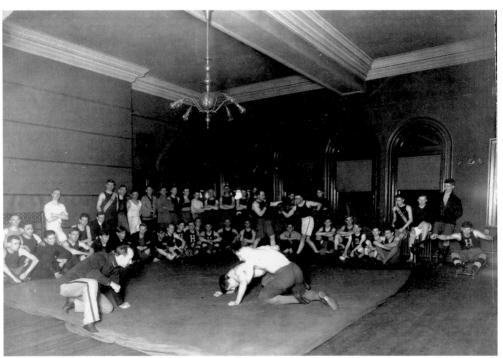

Two unidentified wrestlers are photographed during a match in Homestead. The year of the photograph is not known. (Courtesy of Carnegie Library of Homestead.)

Johnny Alzo first touched a "real" basketball when he was around 12 years old. He first played the game as a young boy with a makeshift backboard and a small rubber ball. He and his friends would fasten a galvanized water bucket with a hole in the bottom to a telegraph pole on his street and shoot the rubber ball through it. They scoured the banks of the local river after a storm for old balls that would wash up, or sold scrap metal to buy a ball at the local five-and-dime store. Alzo went on to be a standout on the Duquesne High School basketball team and played semiprofessional ball until the age of 37, setting several scoring records along the way. (Courtesy of Lisa A. Alzo.)

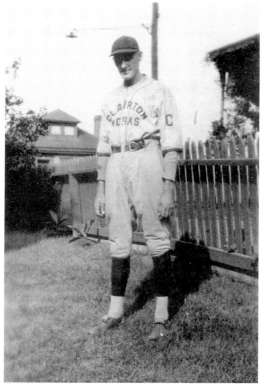

Robert Barnes Brown is dressed in his Clairton Works baseball team uniform in this 1920s photograph that was taken in the backyard of the home of his father-in-law, Thomas Bell Rhine, on Glenn Street in Wilson Borough, Jefferson Township, Allegheny County. (Courtesy of Elizabeth Banzen.)

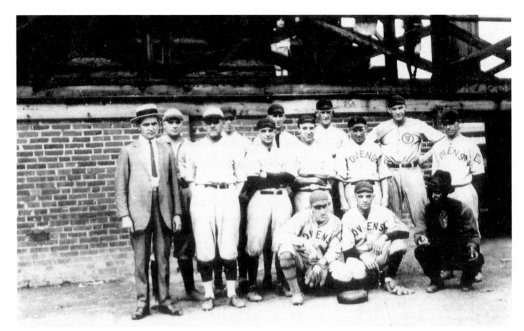

Bucky Howell (second row, fifth from right) and Robert Barnes Brown (second row, second from right) pose with their fellow unidentified teammates in the 1921 photograph of the Clairton Works Ovens baseball team taken at the Clairton Worsk, Jefferson Township, Allegheny. (Courtesy of Elizabeth Banzen.)

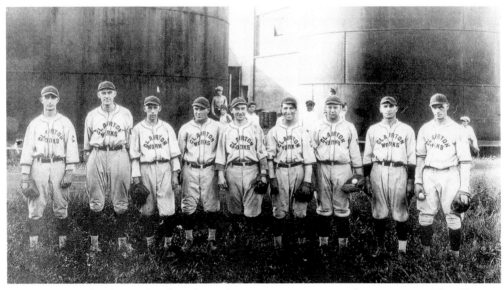

It was common for the steel mills to have their very own intramural sports teams. The Clairton Works baseball team is shown in this 1920s photograph taken at the Clairton Works, Jefferson Township, Allegheny County. Robert Barnes Brown stands second from the left, while Frederick Fielding Rhine is on the right. The names of the remaining team members are not known. (Courtesy of Elizabeth Banzen.)

FOR THE LOVE OF THE GAME

Many of the local businesses, such as the Firth Sterling Steel Company plant in the Pittsburgh suburb of McKeesport, sponsored sports teams in leagues in the 1940s and 1950s. Firth Sterling pioneered high-speed steel output in 1902 and produced the first stainless steel in the United States in 1913. The proud Firth Sterling basketball team poses in this 1950s photograph. (Courtesy of John Alzo.)

Sports such as basketball provided an outlet for recreation and socialization. This 1950s photograph shows the proud USA Local 1256 team of the U.S. Steel Plant in Duquesne receiving a large trophy for their second-place finish in the national championship. (Courtesy of John Alzo.)

5

FROM DIAMOND TO HARDWOOD, ICE TO TURF

The venues that once hosted key sporting events have become iconic in their own right: Duquesne Gardens, Exposition Park, Forbes Field, Pitt Stadium, and Three Rivers Stadium, among others. Also a part of the legend are the "Friday Night Lights" of the countless high school football stadiums, and the electrifying atmosphere of the old high school or college gymnasiums with the sounds of the roaring crowds and stomping bleachers as the home team took the court. The images in this chapter capture the atmosphere of the diamonds, ice rinks, hardwood, and turf where some of the greatest athletes in the world once played.

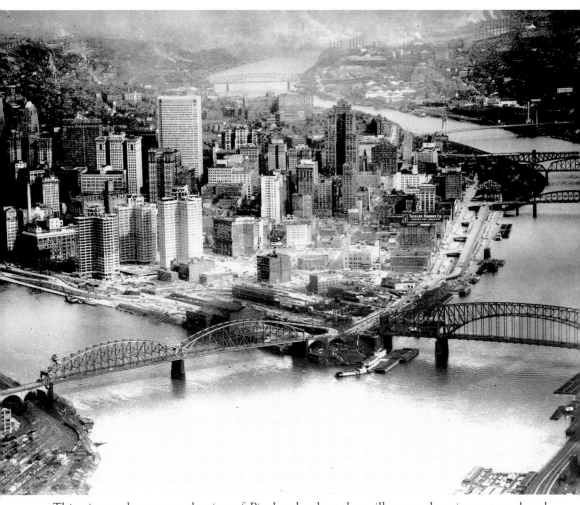

This picture shows an early view of Pittsburgh when the mills were churning out steel and its neighboring towns were celebrating the accomplishments of many great sports teams and individual athletes. (Courtesy of Photo Antiquities Museum of Photographic History.)

FROM DIAMOND TO HARDWOOD, ICE TO TURF

This early photograph (taken between 1900 and 1915) shows a shady tree on the grounds of the Pittsburgh Golf Club in historic Schenley Park. (Courtesy of Library of Congress, Prints and Photographic Division, Detroit Publishing Company Collection.)

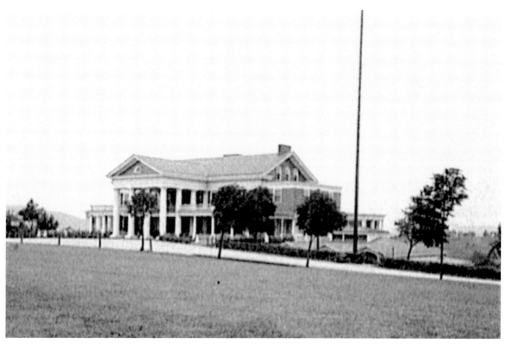

Here is a regal image of the Pittsburgh Golf Club in Pittsburgh, taken sometime between 1910 and 1920. (Courtesy of Library of Congress, Prints and Photographic Division, Detroit Publishing Company Collection.)

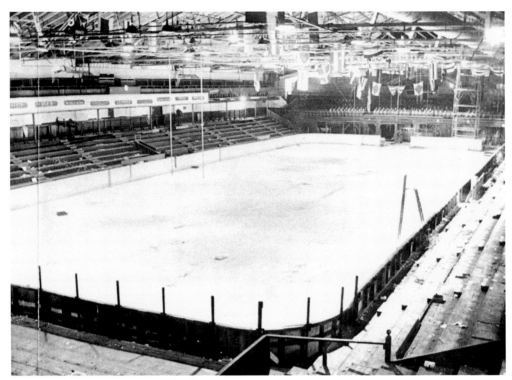

Duquesne Gardens, which opened in 1899, was home to the world's first semiprofessional hockey league. Its 26,000-square-foot indoor rink was then the world's largest artificial ice surface. (Courtesy of Library and Archives Division, Historical Society of Western Pennsylvania, Pittsburgh.)

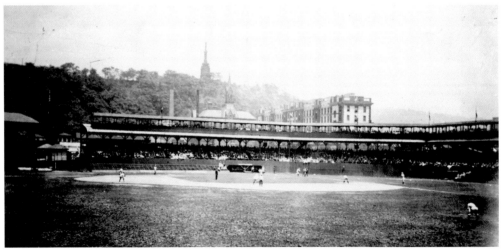

This photograph provides a view of old Exposition Park on Pittsburgh's North Side in 1914, when the Federal League was endeavoring to establish itself in Pittsburgh. The Pirates used this field until the summer of 1909 when they moved to Forbes Field and the World Series that year. The seating capacity was approximately 10,000. (Courtesy of Carnegie Library of Pittsburgh.)

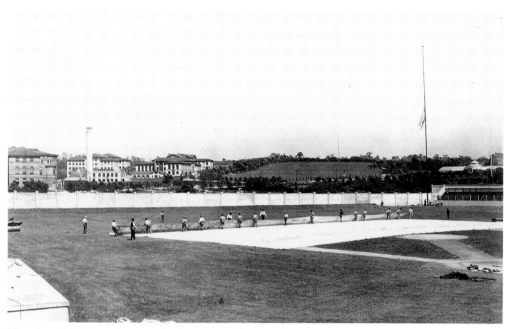

This June 20, 1909, photograph shows a nearly complete Forbes Field in Pittsburgh. (Courtesy of Photo Antiquities Museum of Photographic History.)

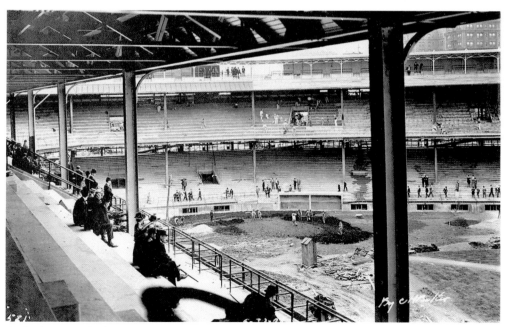

Onlookers watch the preparation of Forbes Field in Pittsburgh in this May 1909 photograph. (Courtesy of Photo Antiquities Museum of Photographic History.)

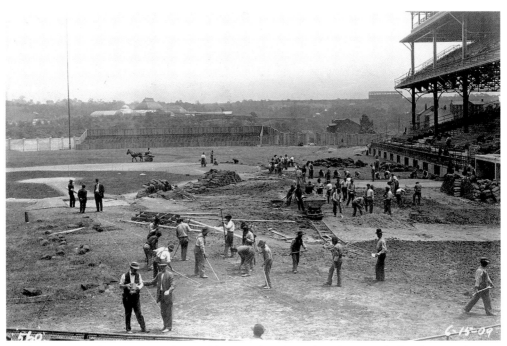

Workers prepare the grass at Forbes Field in Pittsburgh in this photograph dated June 15, 1909. (Courtesy of Photo Antiquities Museum of Photographic History.)

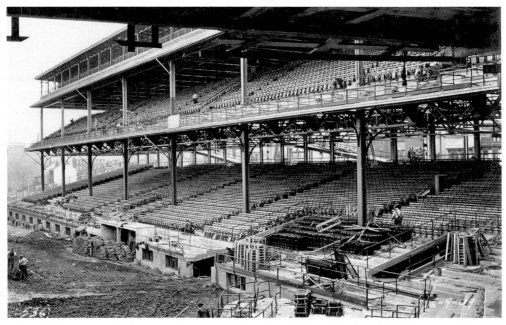

This 1909 photograph shows an "in-progress" Forbes Field in Pittsburgh. Workers can be seen installing the bleachers and preparing the field. (Courtesy of Photo Antiquities Museum of Photographic History.)

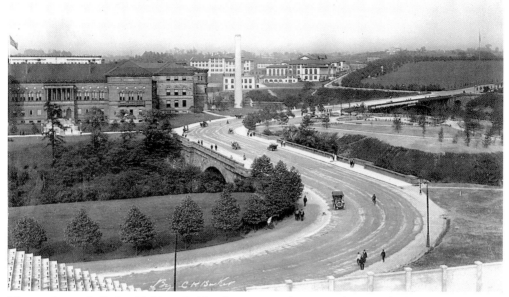

The road outside Forbes Field in Oakland is seen in this 1909 photograph. (Courtesy of Photo Antiquities Museum of Photographic History.)

This photograph shows Munhall's West Field around 1931. The field, located in Munhall, is the historic home of the famous Negro League baseball teams: the Homestead Grays and Pittsburgh Crawfords. (Courtesy of Carnegie Library of Homestead.)

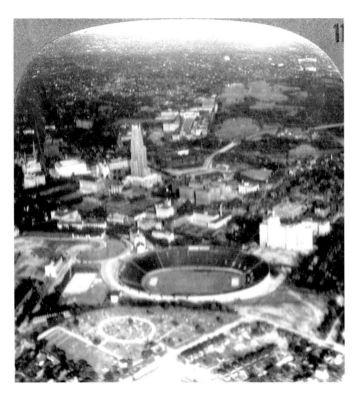

This undated photograph shows an aerial view of Oakland, with Pitt Stadium in the foreground. Another prominent sporting venue visible in this photograph is Forbes Field, shown at the right of Schenley Park's entrance, which is the white square at the right and back of the 40-story Gothic Cathedral of Learning structure. (Courtesy of Photo Antiquities Museum of Photographic History.)

An undated photograph shows an aerial view of Pitt Stadium. The stadium was home to the University of Pittsburgh Panthers football team from 1925 through 1999. It had a capacity of 56,150 people. The Pitt Panthers now play at Heinz Field, which is shared with the Pittsburgh Steelers. The Petersen Events Center is now located on this site. (Courtesy of Photo Antiquities Museum of Photographic History.)

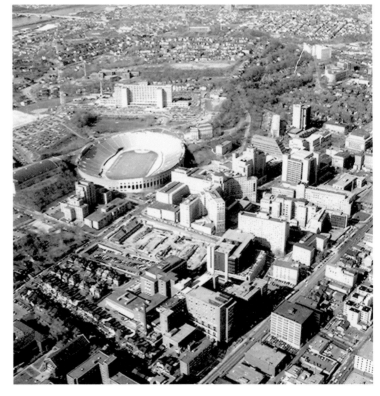

Prominently seen in this undated photograph is the Pittsburgh Civic Arena (now known as Mellon Arena). The arena was completed in 1961 at a cost of $22 million. Originally built to house the Civic Light Opera, the Mellon Arena is now home to the NHL Pittsburgh Penguins and a variety of family shows and concerts. The Mellon Arena is famous for its revolutionary architectural design, which features the largest retractable dome roof in the world—170,000 square feet and 2,950 tons of Pittsburgh steel. Despite its size, the dome can open or close in an amazing two minutes. Another former Pittsburgh landmark, Three Rivers Stadium, can be seen diagonally in the photograph at back. (Courtesy of Photo Antiquities Museum of Photographic History.)

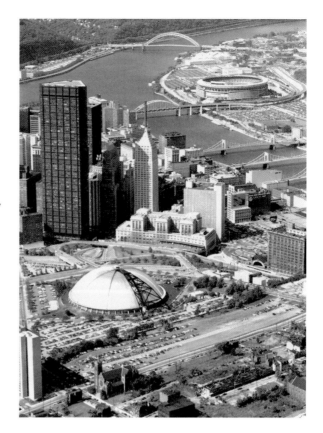

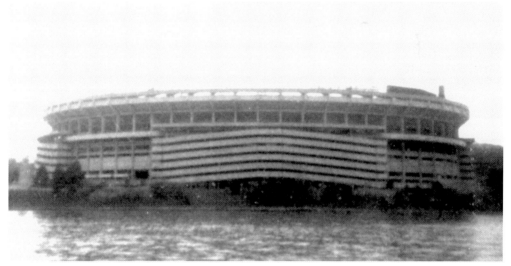

This exterior view is of Pittsburgh's Three Rivers Stadium, home to Pittsburgh's professional baseball and football teams—the Pittsburgh Pirates and the Pittsburgh Steelers—from 1970 to 2001. The stadium was demolished on February 11, 2001, and new, separate venues built for each team were built. For the Pirates it was PNC Park, and for the Steelers, Heinz Field. (Courtesy of Lisa A. Alzo.)

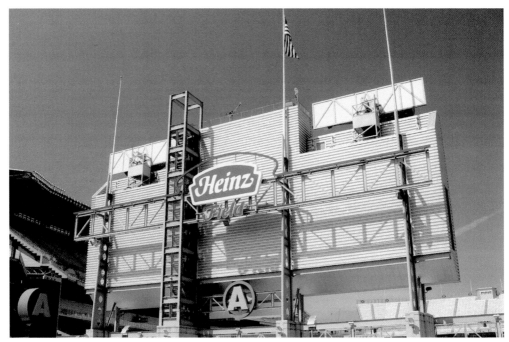

This 2007 photograph shows the exterior of Heinz Field, which opened in 2001, the home field of the Pittsburgh Steelers and the University of Pittsburgh Panthers. With a seating capacity of 64,000, it is also a venue for concerts and other popular events. (Courtesy of Daniel J. Burns.)

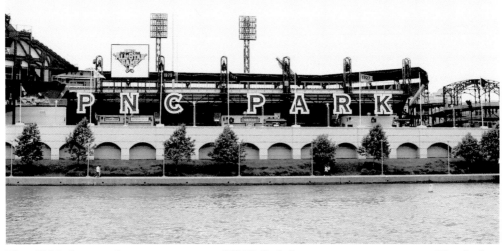

This 2006 photograph captures a view of PNC Park from a unique perspective. The facility, which opened in the spring of 2001, is a ballpark with all the modern-day amenities, yet designed in a classic style reminiscent of such great early venues as Forbes Field, Wrigley Field, and Fenway Park. The park sits in a prime location along the shore of the Allegheny River, with a natural grass field surface and a seating capacity of 38,496. Since April 9, 2001, PNC Park has been the home of the Pittsburgh Pirates baseball team. (Courtesy of Daniel J. Burns.)

6

GREAT PLAYS

There are hundreds of "great plays" associated with western Pennsylvania sports. Who can forget the "Immaculate Reception" in 1972; Billy Conn's near-upset of heavyweight champion Joe Louis in 1941; or Bill Mazeroski's dramatic home run in the seventh game of the 1960 World Series? This chapter highlights some of the most memorable moments in western Pennsylvania sports history.

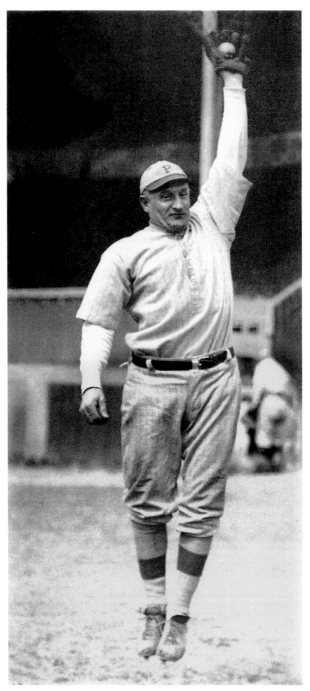

This early 1900s photograph shows the great Honus Wagner demonstrating his exceptional fielding skills. Wagner played shortstop for the Pirates for 17 seasons while compiling a lifetime average of .329 and stealing 722 bases. The Flying Dutchman led the league in thefts on five occasions. His teammate Tommy Leach said this of Wagner, "He wasn't just the greatest shortstop ever. He was the greatest everything ever." (Courtesy of Leslie Wagner Blair.)

GREAT PLAYS

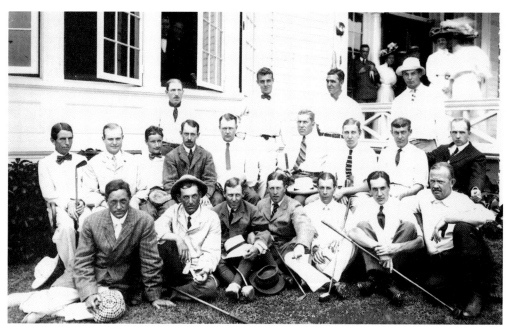

Many prominent golfers appear in this 1907 photograph taken at the Allegheny Country Club where they gathered to honor the newly crowned National Amateur Champion Jerome D. Travers who is in the second row, third from left. (Courtesy of Carnegie Library of Pittsburgh.)

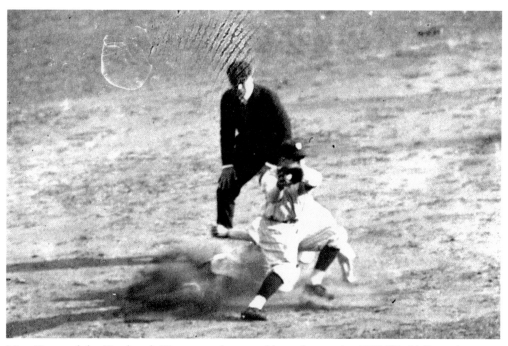

Max Carey of the Pittsburgh Pirates steals second base during the 1925 World Series between the Washington Senators and the Pirates. This photograph was taken on October 11, 1925. (Courtesy of Library of Congress, Prints and Photographic Division.)

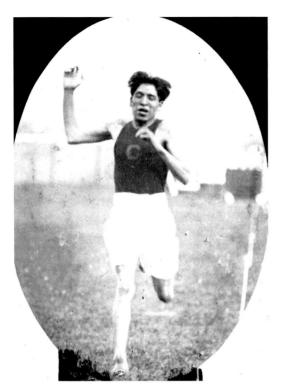

This undated action shot is of Louis Tewanina, a Hopi Indian from Carlisle School who ran in two Olympiads (1908, 1912), as he appeared at Forbes Field in Pittsburgh. (Courtesy of Carnegie Library of Pittsburgh.)

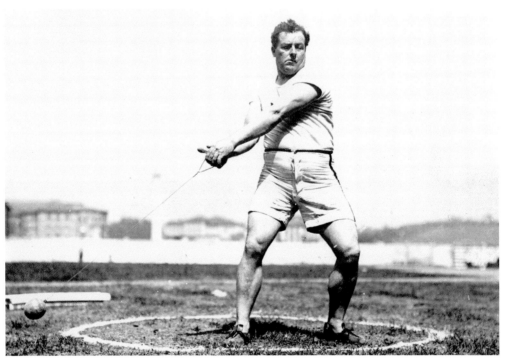

Matt McGrath, Olympic games champion, participates in an athletic meet at Forbes Field in 1909. (Courtesy of Carnegie Library of Pittsburgh.)

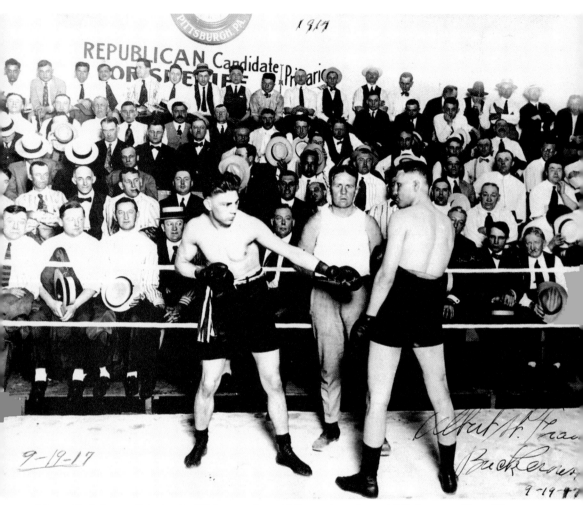

Harry Greb began fighting in 1913, won the middleweight title in 1923, lost it to Tiger Flowers in 1926, and died nine months later while undergoing eye surgery. He is shown here before knocking out Buck Crouse at Exposition Hall on July 2, 1917. (Courtesy of Carnegie Library of Pittsburgh.)

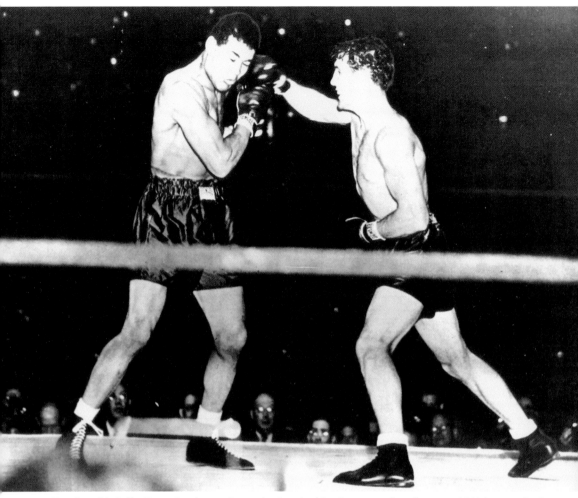

Pittsburgh's Billy Conn lands a right to the head of Joe Louis in their historic 1941 bout, which boxing experts often refer to as the best fight ever. (Courtesy of Tim Conn.)

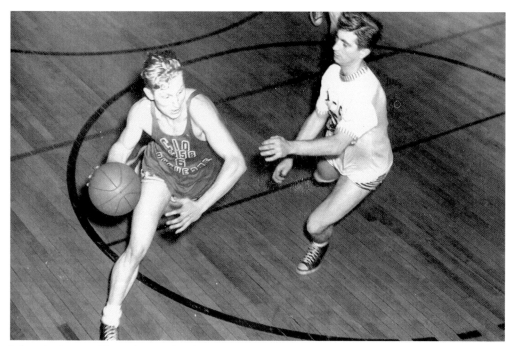

John "Whitey" Alzo, playing for the Duquesne CIO basketball team, drives past a defender during a game in this undated photograph. (Courtesy of John Alzo.)

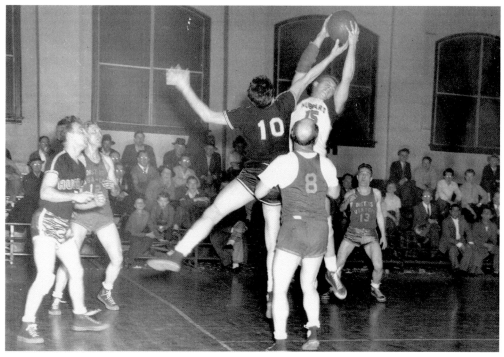

Fans and players watch a battle for the basketball between the District 15 and 18 teams during a USA-CIO tournament in this undated photograph. (Courtesy of John Alzo.)

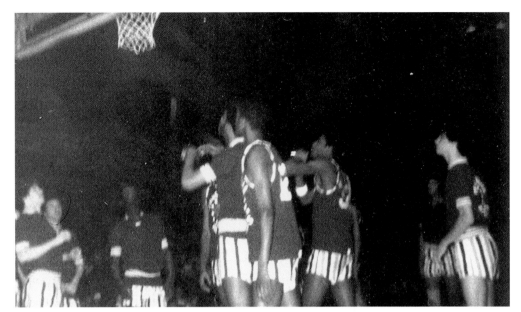

In 1965, Sonny Vaccaro and Pat DiCesare originated the Roundball Classic that at one time was the premier all-star basketball game in the country. A total of 16,649 fans attended the 1979 game, the highwater mark for the Roundball. The game started to fade into history in 1986 when the decision was made to no longer have a Pennsylvania team but instead offer a national format with teams representing North, South, East, and West. The game folded in 1992. This photograph shows the West All-Stars warming up before a 1980s contest. (Courtesy of Lisa A. Alzo.)

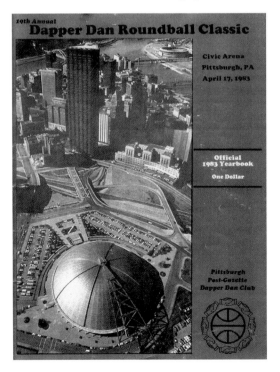

This official yearbook commemorates the 19th annual Dapper Dan Roundball Classic sponsored by the Pittsburgh Post-Gazette Dapper Dan Club held on April 17, 1983, at the Civic Arena. (Courtesy of Lisa A. Alzo.)

This photograph shows Latrobe native Arnold Palmer in action. His daring, come-from-behind style of play and his dynamic personality made Palmer the most popular professional golfer of all time. (Courtesy of Arnold Palmer Enterprises.)

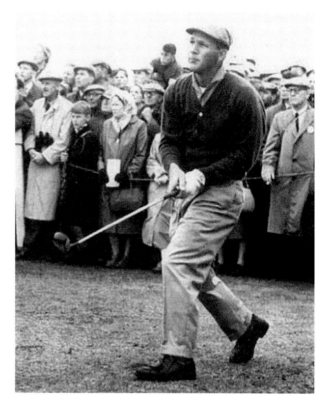

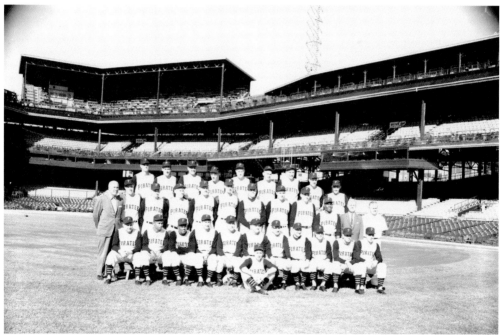

This team photograph depicts the Pittsburgh Pirates—1960 World Series Champions. (Courtesy of Carnegie Library of Pittsburgh.)

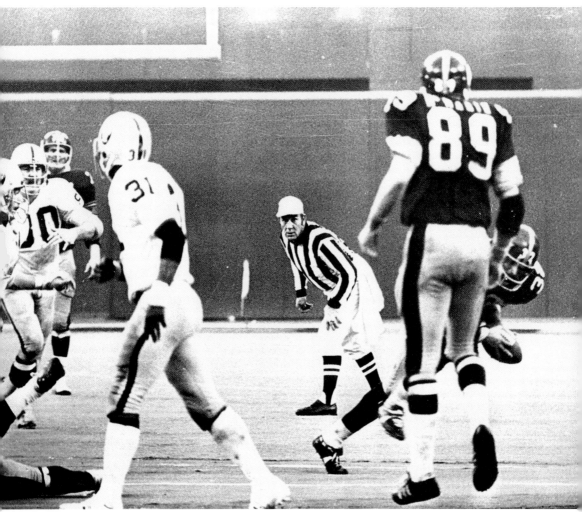

The "Immaculate Reception" is the nickname given to one of the most controversial plays in the history of American football. It occurred in the AFC divisional playoff game between the Pittsburgh Steelers and the Oakland Raiders at Three Rivers Stadium in Pittsburgh on December 23, 1972. NFL Films selected it as the greatest play of all time. (Courtesy of the Pittsburgh Steelers.)

7

THE LOCKER ROOM

While most of the attention is paid to the athletes on the field, what goes on behind the scenes is often ignored. Owners, coaches, families, support staff, workers, and sponsors can also help an athlete or team achieve greatness. These unsung heroes deserve recognition as well. The images on the following pages document some of the people and institutions that played instrumental roles in the sports history of western Pennsylvania.

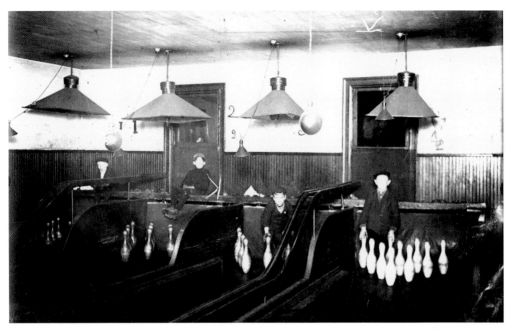

This 1908 or 1909 photograph by Lewis W. Hine shows pin-boys working until late at night in this unidentified Pittsburgh bowling alley. (Courtesy of Library of Congress, Prints and Photographic Division, Detroit Publishing Company Collection.)

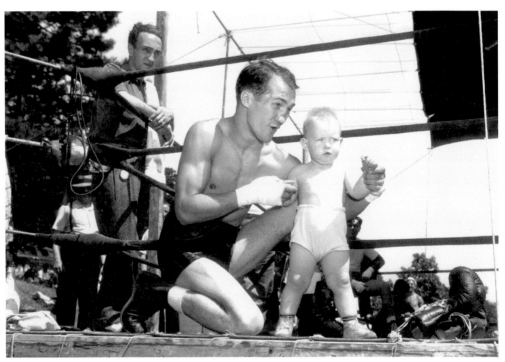

An unidentified boxer gives some pointers to a possible future champ in this undated photograph. (Courtesy of Photo Antiquities Museum of Photographic History)

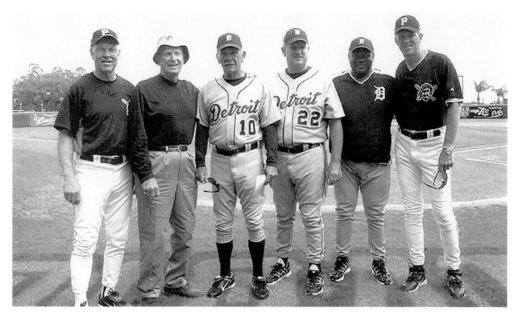

At a spring training game in March 2007, every Pirates manager since 1972 gathered for a rare photograph. Going into the 2007 season, seen here from left to right, Bill Virdon, Chuck Tanner, Jim Leyland, Gene Lamont, Lloyd McClendon, and Jim Tracy had combined for almost 4,500 major-league wins. (Courtesy of the Pittsburgh Pirates.)

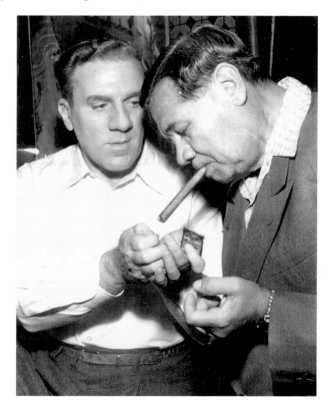

Babe Ruth (right) takes a break to enjoy a cigar in this undated photograph. (Courtesy of Photo Antiquities Museum of Photographic History.)

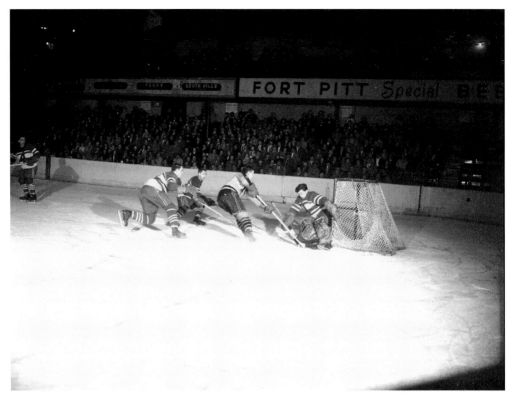

The Pittsburgh Hornets of the National Hockey League are shown in action at the Duquesne Gardens in the 1950s. (Courtesy of Carnegie Library of Pittsburgh, photograph by Paul Slantis.)

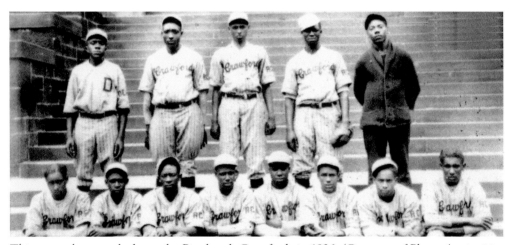

This team photograph shows the Pittsburgh Crawfords in 1926. (Courtesy of Photo Antiquities Museum of Photographic History.)

THE LOCKER ROOM

This photograph by Paul Slantis shows the Pittsburgh Condors of the American Basketball Association taking on Carolina during the 1971–1972 season at the Civic Arena. (Courtesy of Carnegie Library of Pittsburgh.)

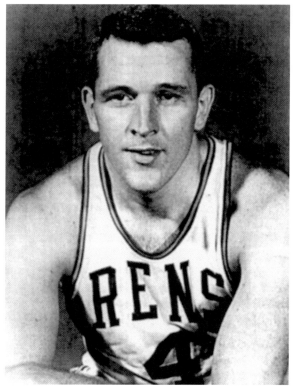

John Cincebox, seen in this 1960s photograph, played for the Pittsburg Rens basketball team of the American Basketball League. (Courtesy of John and Helen Cincebeaux.)

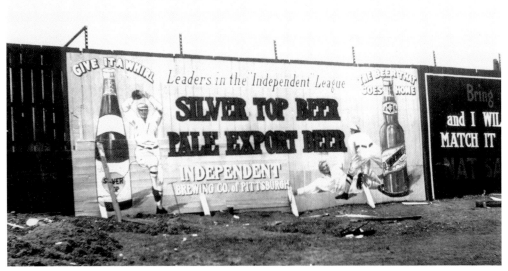

Advertising and sports have enjoyed a long association. Here a sign in Pittsburgh advertises "Silver Top Beer Pale Export Beer" from the Independent Brewing Company of Pittsburgh, with slogans "give it a whirl" and "the beer that goes home," using images of baseball players. (Courtesy of Photo Antiquities Museum of Photographic History.)

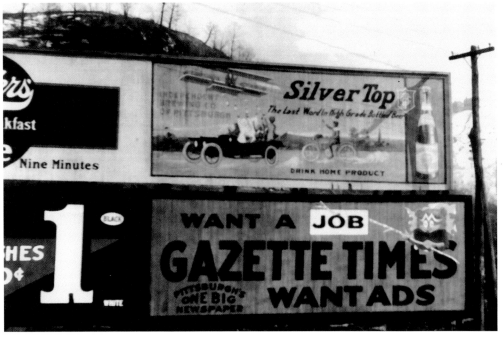

A sign advertises the Independent Brewing Company of Pittsburgh and its Silver Top Beer is shown in this undated photograph. (Courtesy of Photo Antiquities Museum of Photographic History.)

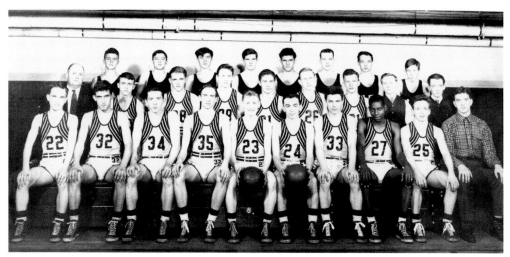

The 1943 Duquesne High School varsity men's basketball team shown here in this team photograph posted a 15-8 season record and won six league games while losing two. For the second straight year, loss of a key player by the personal foul route hurt Duquesne's chances for advancing in the Western Pennsylvania Interscholastic Athletic League tournament as the local club dropped from the championship race after bowing to North Braddock Scott 37-33 in a quarter-final game at Pitt Stadium. The banishment of Big Ed Little (No. 35) deprived the Dukes of their "big" man, and speedy forwards Mike Belich (No. 24) and John Alzo (No. 23) were unable to carry the load. (Courtesy of John Alzo.)

This image is of the anniversary booklet prepared in honor of the Duquesne High School "Dazzling Dukes" celebrating 32 years of basketball. (Courtesy of Lisa A. Alzo.)

This 1973 souvenir program is for the Pennsylvania Interscholastic Athletic Association Boys and Girls Basketball finals held at the Farm Show Arena in Harrisburg. (Courtesy of John Alzo.)

This image is of a souvenir program from the 1969 Pennsylvania Interscholastic Athletic Association State Championship Basketball Games held March 21–22, 1969, at the Farm Show Arena in Harrisburg. (Courtesy of John Alzo.)

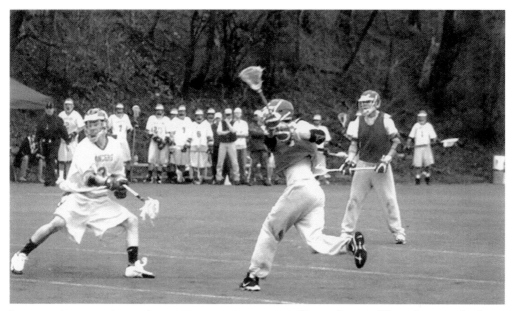

Lacrosse is a popular and growing sport in western Pennsylvania. This photograph shows Mount Lebanon High School star Zach Boyt scoring a goal in a 2007 early-season tournament game. Mount Lebanon is a perennial power in the Western Pennsylvania Scholastic Lacrosse Association, having won the WPSLA tournament four times between 2000 and 2006. (Courtesy of Alby Oxenreiter.)

This photograph shows Baldwin player Todd Augenstein walking off the field after a match with Mount Lebanon in April 1996. (Courtesy of Todd Augenstein.)

In this undated photograph, Art Rooney, owner of the Pittsburgh Steelers football team, is shown with jockey Eddie Arcaro. Coincidentally Rooney funded the purchase of his football franchise in 1932 by a win on the horses. (Courtesy of Carnegie Library of Pittsburgh.)

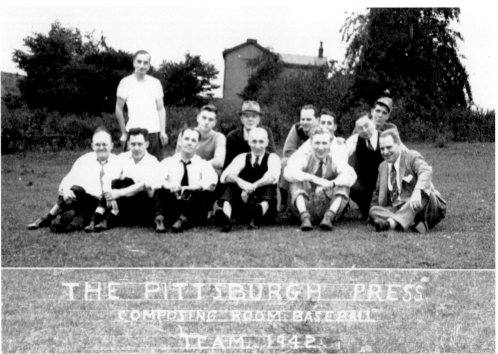

The Composing Room baseball team of the *Pittsburgh Press* newspaper poses for this 1942 photograph. (Courtesy of Photo Antiquities Museum of Photographic History.)

8

The Men Behind

the Microphone

For decades, the announcers who brought the games to life on radio and television became as popular as the athletes and the events, and so did their signature catchphrases such as "Yoi," "Kiss it goodbye," and "Michael, Michael motorcycle." These "men behind the microphones" were legendary in their own right. This chapter celebrates a few of the area's most notable announcers.

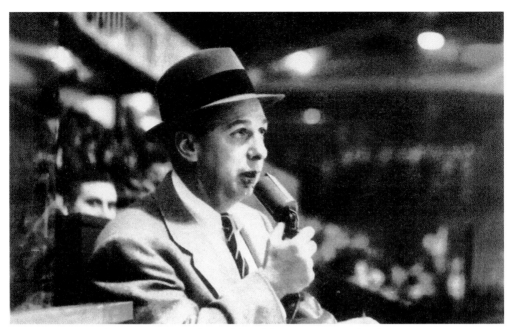

Ray Downey was the Pittsburgh Steelers public address announcer for close to 50 years. Downey also announced for the Pittsburgh Hornets of the American Hockey League. This photograph was taken at the old Duquesne Gardens. (Courtesy of Alby Oxenreiter.)

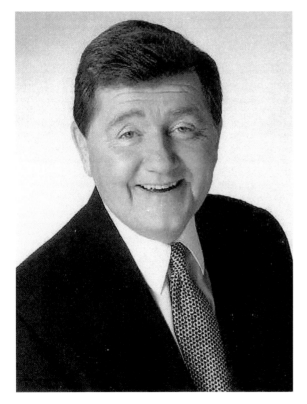

Pittsburgh native Bill Hillgrove has been an important part of the city's sports history. Hillgrove has been the play-by-play voice of the Steelers since 1994. Hillgrove has also called the play-by-play of Pitt basketball since 1969, and has been the voice of Pitt football since 1974. (Courtesy of Bill Hillgrove.)

THE MEN BEHIND THE MICROPHONE

Pirates announcer Bob Prince is a Pittsburgh institution. Prince was the 1986 recipient of the Ford C. Frick Award. Prince was a "Pittsburgh original," and his unique style and sense of humor made him an instant fan favorite. Prince began broadcasting with Rosey Roswell on the Pirates radio broadcasts in 1948, and his affiliation with the ball club spanned five decades. Because of his rapid-fire play-by-play, Prince was nicknamed "the Gunner." Prince's "colorful" attire matched his flamboyant personality. (Courtesy of Alby Oxenreiter.)

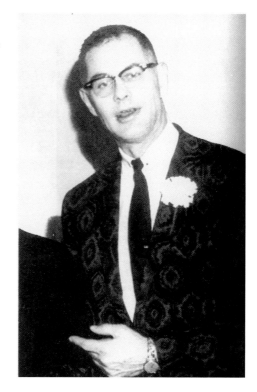

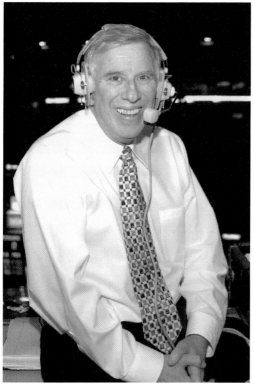

Mike Lange, the longtime "Voice of the Penguins," was honored with the 2001 Foster Hewitt Memorial Award for his outstanding work as an NHL broadcaster. Lange has been calling the play-by-play of the Pens since the early 1970s. His distinctive style has made him as popular as the players. Lange is known across the league for his unique catch phrases, such as "Michael, Michael motorcycle!" (Courtesy of Matt Polk/Pittsburgh Penguins.)

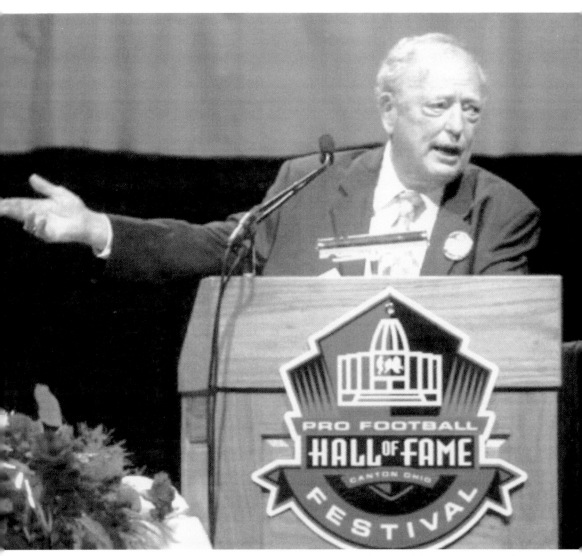

Myron Cope was the Steelers' radio analyst for 35 years and host of the *Myron Cope Show* on WTAE radio. He was inducted into the Radio Hall of Fame in 2005. A graduate of Allderdice High and the University of Pittsburgh, Cope began his newspaper career in Erie before moving to Pittsburgh in the 1950s. During the 1960s, Cope was also a prominent writer for *Sports Illustrated* and other national publications. In the early 1970s, Cope became one of the city's pioneer sports radio talk show hosts. In 2005, Cope was also selected as the 2005 recipient of the Pro Football Hall of Fame's Pete Rozelle Radio-Television Award. The award, given annually by the hall of fame, recognizes "long-time exceptional contributions to radio and television in professional football." Cope also created the Terrible Towel. (Courtesy of Scott Heckel and Bob Rossiter.)

THE MEN BEHIND THE MICROPHONE

9

FANFARE

"You're in Steeler Country!" "Welcome to Blitzburgh!" "Hail to Pitt!" Sports fans in western Pennsylvania have always been a loyal and vocal lot. Whether it was a crowd of 10,000 that turned out to watch a local or regional all-star baseball game, the legions that packed the local high school gymnasiums to cheer on their high school basketball team, or the throngs of Steelers fans at Three Rivers Stadium (and now Heinz Field) waving their Terrible Towels, support for the area's sports teams and athletes is proudly and often loudly displayed. Although other cities might be tempted to argue the point, it could be said that Pittsburgh fans are in a league of their own. The images in this chapter focus on these dedicated fans.

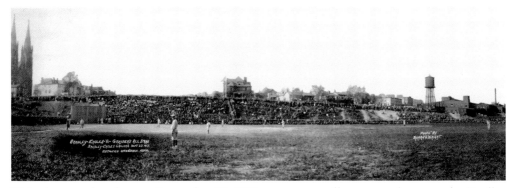

This photograph, taken on September 23, 1917, captures an all-star game between the Bradley Eagles and Grayber's all-stars. The estimated attendance was 10,000. (Courtesy of Photo Antiquities Museum of Photographic History.)

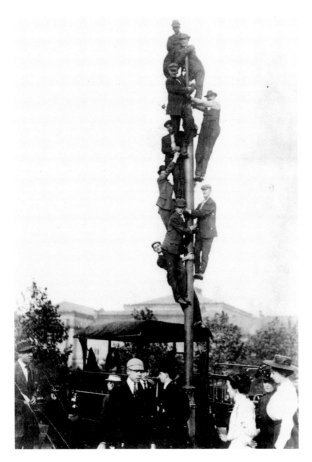

Some fans will go to great lengths to see their favorite team in action. The back of this photograph reads: "Spectators in Pittsburgh who have climbed on a tall pole to observe the baseball game between Pittsburg[sic]-Detroit game in 1909, while other people in foreground look on." (Courtesy of Library of Congress, Library of Congress Prints and Photographs Division.)

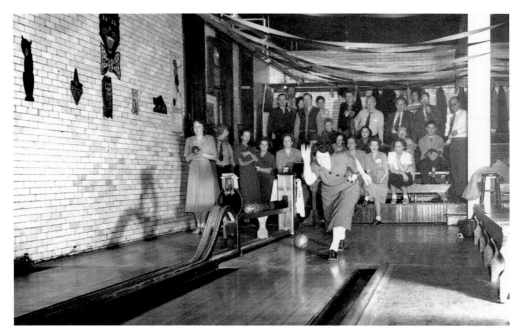

Bowling was a popular pastime with men and women at the Carnegie Library in Homestead and drew a number of spectators, as seen in this undated photograph. (Courtesy of Carnegie Library of Homestead.)

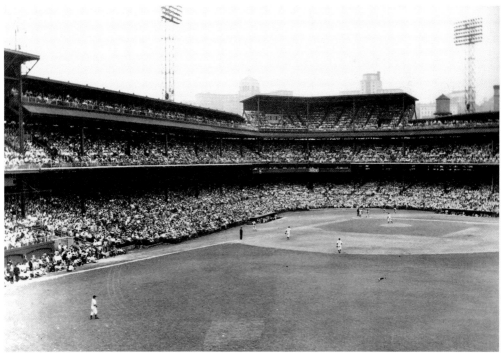

Fans filled sporting venues to capacity even in the early 1900s, as evidence by this photograph of Forbes Field in Pittsburgh. (Courtesy of Photo Antiquities Museum of Photographic History.)

A large crowd gathers to watch the Ambridge baseball team shown in this 1920s photograph.

(Courtesy of Photo Antiquities Museum of Photographic History.)

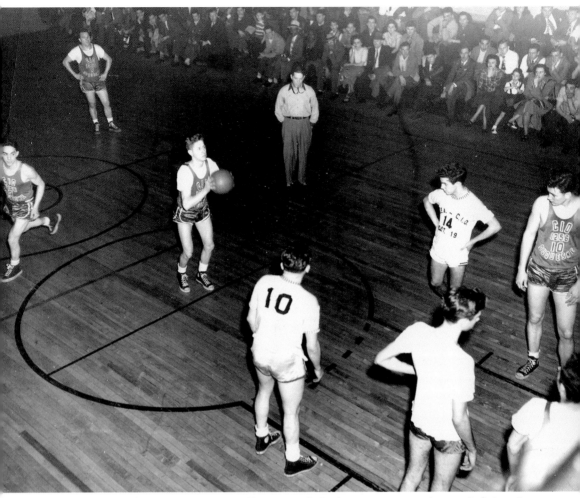

Many fans watch in anticipation as a Duquesne CIO player prepares to shoot a foul shot during a 1950s basketball game. Notice how the fans are dressed in their Sunday best—the men in suits and ties and the women in dresses, compared to the casual attire fans don today. (Courtesy of John Alzo.)

AMERICAN LEAGUE
PROFESSIONAL BASE BALL CLUBS
STRAUS BUILDING
CHICAGO

September
7,
1 9 2 8.

Mr. W. F. Oxenreiter,
c/o Gimbel Brothers,
Pittsburgh, Pa.

My dear Mr. Oxenreiter:

 I have your recent favor and have care-
fully noted your suggestion in regard to the numbering
of players in the World's Series, and I feel there is
considerable merit in the idea. Am sending your letter
to Commissioner K. M. Landis, who has entire charge of
these games.

 Very truly yours,

 ESB Barnard

ESB:DH President.

In 1928, Pittsburgh resident William Oxenreiter, faced with the frustration of not being able to distinguish baseball players on the field, sent a letter to the presidents of both the National and American Leagues. Oxenreiter suggested that teams start using numbers on the backs of their jerseys to make it easier for fans to follow the action during that year's World Series. Oxenreiter received a response in the form of a letter from American League president Ernest Barnard, who wrote that there was "considerable merit in the idea." Barnard promised to pass along the idea to baseball commissioner Kenesaw Mountain Landis. Six months later, in the spring of 1929, Oxenreiter's idea was adopted when the Yankees and Indians became the first major-league teams to permanently use numbers on the back of their jerseys. (Courtesy Alby Oxenreiter.)

Fans flock to meet the Pittsburgh Steelers each summer at their training camp facilities at St. Vincent College in Latrobe. In this 1980s photograph, Lisa Alzo poses with her favorite Pittsburgh Steeler—all-pro linebacker Jack Ham, who played for the Steelers from 1971 to 1982. Ham was inducted into the Pro Football Hall of Fame in 1988. (Courtesy of Lisa A. Alzo.)

Devoted Pittsburgh Steelers fans can be found even in far-flung places. This photograph shows former Pittsburgh resident Helen Lizanov holding her Terrible Towel in front of her black and gold decorated Houston home cheering on the Steelers during their fifth Super Bowl victory in February 2006. (Courtesy of Helen Lizanov.)

A pierogi race takes place between innings of a Pirate baseball game at PNC Park. Pittsburgh was a magnet for Eastern European immigrants during the 19th and 20th centuries, and the pierogi (a type of dumpling filled, usually, with potato, and sometimes cheese, onions, or other ingredients) is a popular food item in the region. In the "Great Pierogi Race," animated pierogies race through Pittsburgh on the Jumbotron. Eventually they "reach" the stadium and life-size pierogies (humans dressed in costume) race into the stadium to a makeshift finish line. (Courtesy of Corey Bower.)

The pierogies each had their own personality/filling, such as Chester Cheese, Jalapeño Hannah, Oliver Onion, Potato Pete, and Sauerkraut Saul. In this photograph the pierogies enter the stadium and greet fans along with the Pirate Parrot mascot during a Pittsburgh Pirates baseball game in 2003 at PNC Park. (Courtesy of Corey Bower.)

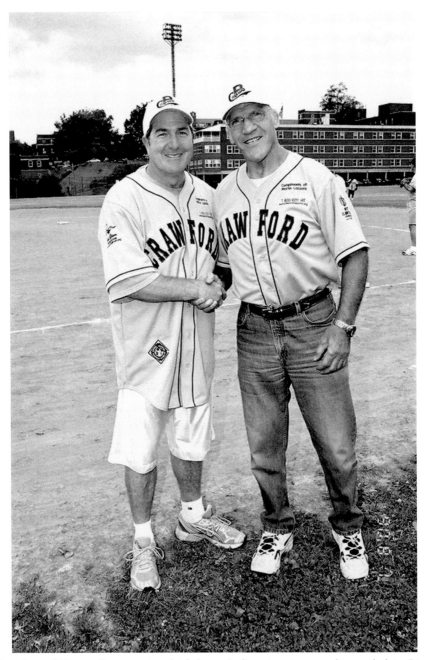

Wrestling legend Bruno Sammartino (right), an Italian immigrant who settled in Pittsburgh in 1951, poses with Alby Oxenreiter at a charity softball game before the 2006 Major League Baseball All-Star Game. Sammartino is a professional wrestling icon, and the longest-running champion of the WWWF (World Wide Wrestling Federation). Sammartino held the WWWF title across two reigns for about 12 years total. He is credited with having the longest world championship reign in professional wrestling history. "The Italian Strongman" has sold out Madison Square Garden a record 187 times. (Courtesy of William Carmack.)

10

BRAGGING RIGHTS

Western Pennsylvania's largest city, Pittsburgh, boasts well-known professional teams in baseball, football, and hockey. The grit, dedication, and passion of the players and coaches, and the devotion of loyal fans, all helped to create a rich sports history.

With five World Series championships, five Super Bowl victories, and two back-to-back Stanley Cup titles, Pittsburgh has earned its bragging rights and the nickname "City of Champions."

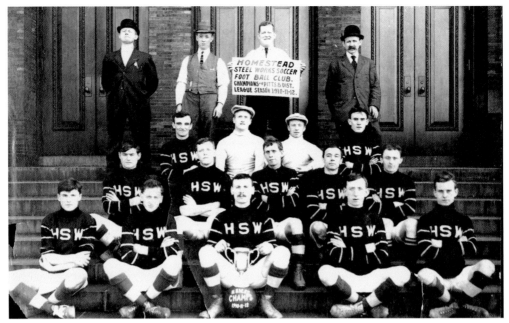

The proud members of the Homestead Steel Works Soccer Foot Ball Club Champions Pittsburgh and District League (season 1910–1912) pose in their uniforms outside the Carnegie Library in Homestead. (Courtesy of Carnegie Library of Homestead.)

Members of the C. J. McBride 1910–1911 team pose for a photograph. (Courtesy of Carnegie Library of Homestead.)

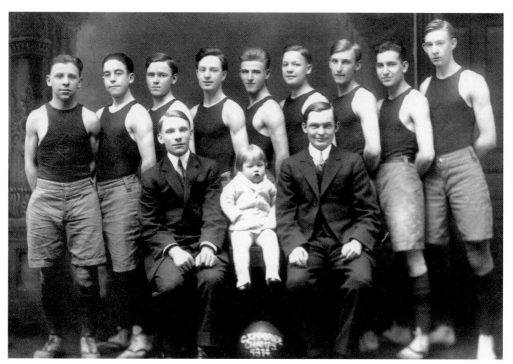

The C. J. McBride basketball team champions for 1913–1914 pose with their unidentified adorable lucky charm. (Courtesy Carnegie Library of Homestead.)

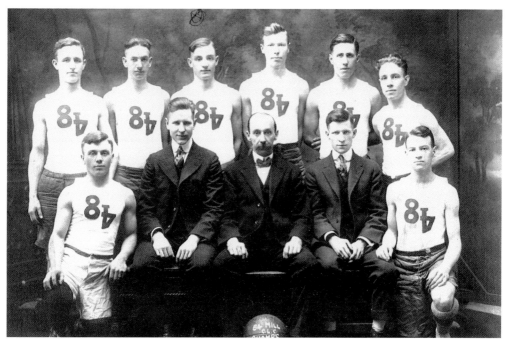

This photograph shows the 1915–1916 "84" Mill Champs basketball team with their unusual jerseys. (Courtesy of Carnegie Library of Homestead.)

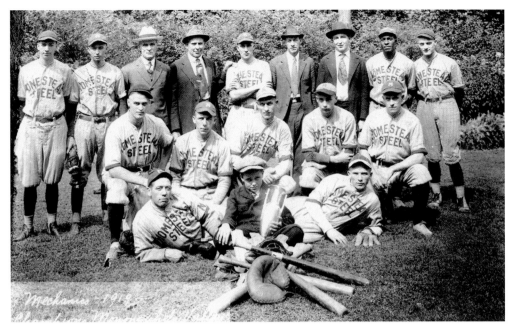

The proud "Mechanics" baseball team, champions of the Monongahela Valley, Homestead Steel Athletic Association, pose with their trophy in this 1919 photograph. (Courtesy of Carnegie Library of Homestead.)

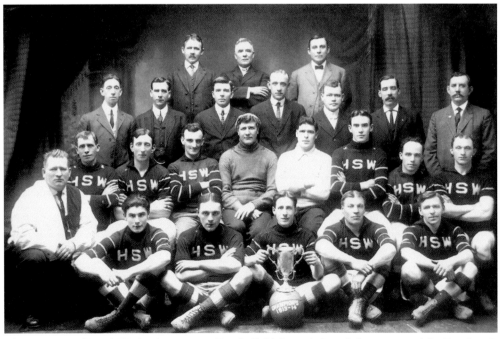

The Homestead Steel Works Association Football Club, undefeated champions of the Pittsburgh and District League in 1913–1914, proudly displays its trophy in this photograph taken in Homestead. (Courtesy of Carnegie Library of Homestead.)

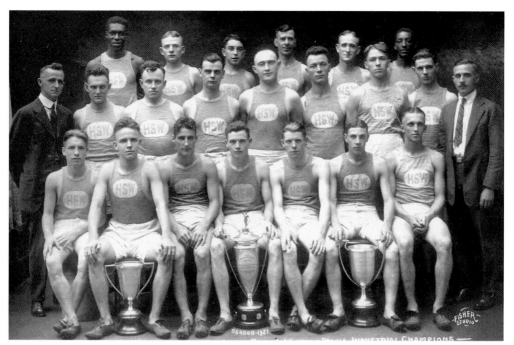

The Homestead Steel Works Track Team of the Carnegie Steel Company, Western Pennsylvania Industrial champions, pose with their trophies in this 1921 photograph. (Courtesy of Carnegie Library of Homestead.)

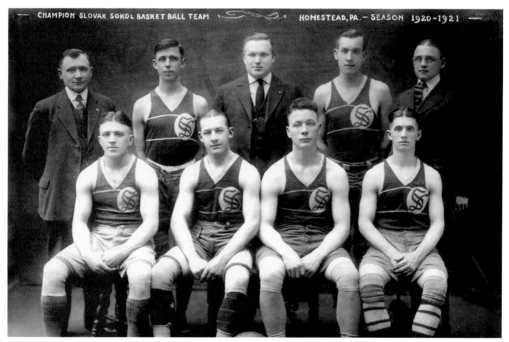

This photograph shows the champion Slovak Sokol basketball team in Homestead from the 1920–1921 season. (Courtesy of Carnegie Library of Homestead.)

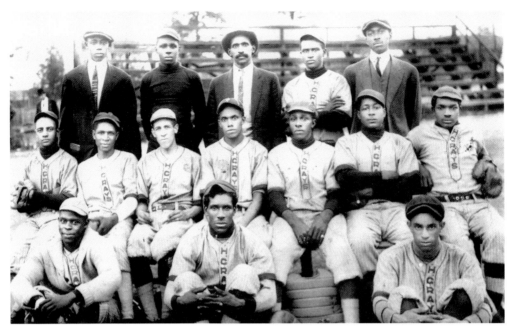

The Homestead Grays was the most storied franchise in the Negro Leagues. Formed in 1912 by Cumberland Posey, the Grays would be in continuous operation for 38 seasons. The Grays captured nine consecutive Negro National League championships and three Negro World Series titles. (Courtesy of Photo Antiquities Museum of Photographic History.)

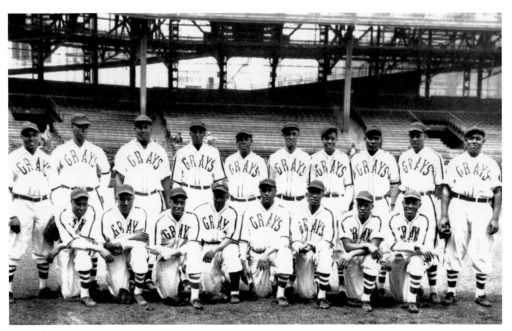

The Homestead Grays were one of the Negro League's most enduring and popular teams, and Negro League baseball champions in 1913. (Courtesy of Photo Antiquities Museum of Photographic History.)

BRAGGING RIGHTS

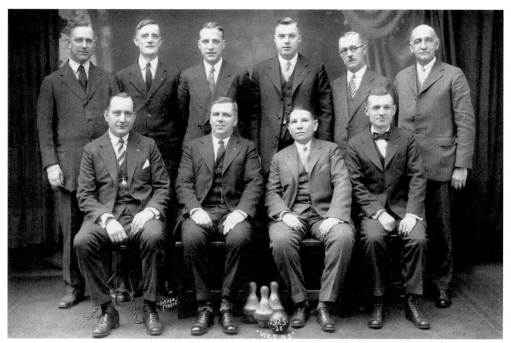

The Wrens, who were the champions of the Homestead Fraternity Club Bowling League, pose in this 1925 photograph. (Courtesy of Carnegie Library of Homestead.)

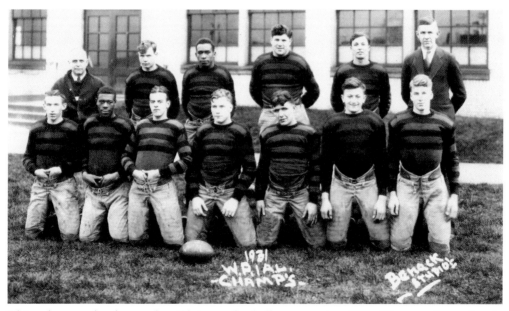

This photograph shows the Clairton football team—the 1931 Western Pennsylvania Interscholastic Athletic League Champs. From left to right are (first row) William Stokes, Leroy Sellers, Mike Kalcevich, Albert Meeleis, George Pavlack, Andy Berchok, and Dick Horn; (second row) George Woodman, John Swetka, Eddie Johnson, Ken Stilley, John Snizik, and William Wyke. (Courtesy of Elizabeth Banzen.)

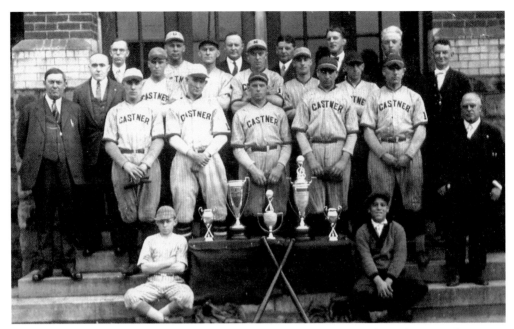

The United States Steel baseball team poses proudly with several trophies in this 1920s photograph. (Courtesy of Elizabeth Banzen.)

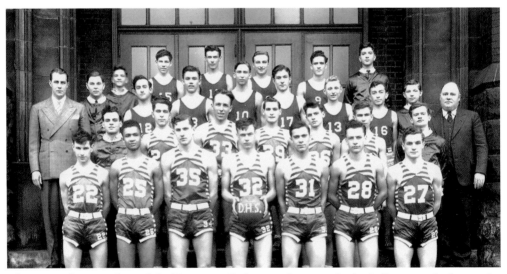

This team photograph is of the Duquesne Dukes men's varsity basketball team, which was the Pennsylvania Interscholastic Athletic Association (PIAA) Western Regional Champions of 1941. This team was the first in the school's history to compete in the state final but failed to win the big one, bowing to Lower Merion, 32-24, in the University of Pennsylvania's Palestra Stadium. It marked the beginning of the "Philadelphia-bound craze" that gripped local fans, and the season produced one of the greatest comebacks in the school's distinguished basketball history when the Dukes overcame a nine-point half-time deficit to trounce a classy Bradford team, 46-34, in a PIAA elimination game. (Courtesy of John Alzo.)

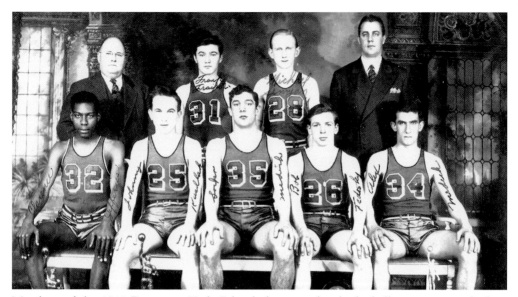

Members of the 1944 Duquesne High School championship basketball team pose with their trophies. From left to right are (first row) Clarence Jefferies, Johnny Kashlak, Mike "Socko" Medich, Bob Tedesky, and Alex Medich; (second row) William Lemmer (coach), Frank Fraikor, Michael Semyan, and Phil Rice (assistant coach). The Dukes defeated Hazleton 43-35 at Convention Hall in Philadelphia for the state championship title. (Courtesy of John Alzo.)

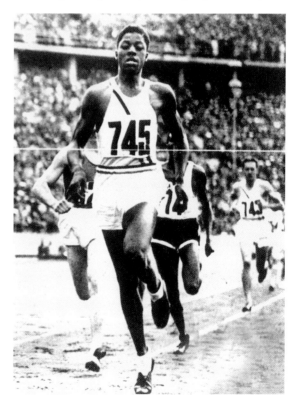

John Woodruff was born in Connellsville in 1915, the grandson of Virginia slaves. Woodruff, an Olympic teammate of Jesse Owens, is shown here winning the gold medal in the 1936 Summer Olympics in Berlin. Woodruff was a 21-year-old Pitt freshman when he finished the 800 meters in 1:52.9, a time that earned him the Olympic gold medal in a race witnessed by Adolf Hitler. Woodruff's gold medal now hangs on a plaque in the University of Pittsburgh's Hillman Library. Woodruff, and all winners at the Berlin games, also received a sapling, which is now a mature tree that stands at the Connellsville High School stadium. (Courtesy University of Pittsburgh.)

This photograph shows the Duquesne Lodge No. 320 team, which won the senior division laurels during the Croatian Fraternal Union's 11th Annual National Basketball Tournament held April 2–4, at Farrell with their trophy. Duquesne floored one of the classiest combinations seen in years. (Courtesy of John Alzo.)

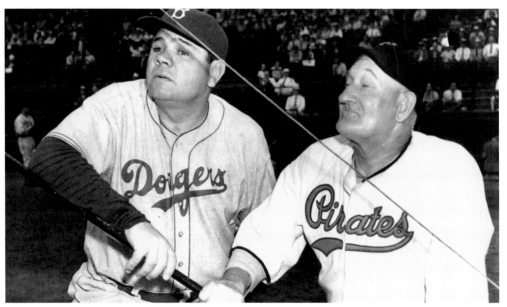

Babe Ruth (left) and Carnegie native Honus Wagner were two of the five original inductees into the National Baseball Hall of Fame. This photograph was taken by photographer James Klingensmith at Forbes Field. Ruth and Wagner are admiring a hit in batting practice. Ruth played for the Boston Red Sox, the New York Yankees, and the Boston Braves. He was later the Brooklyn Dodgers' first base coach for part of one season. Wagner was a star player and later coached for the Pirates. (Courtesy of James Klingensmith.)

George Herman Ruth Jr. was the best-known athlete of his time. Ruth, who was known by his nickname "Babe," is shown here in an early career photograph (right). On May 25, 1935, Ruth hit three home runs at Pittsburgh's Forbes Field (below). One of Ruth's home runs cleared the roof at Forbes Field. As it turned out, they were the final three home runs of Ruth's career. Five days later, he retired from baseball. Ruth's 714th and final major-league home run landed in a construction yard across from Forbes Field and was retrieved by a group of young boys, including Dominic "Woo" Verratti. A quarter century later, Verratti would resurface in another of Pittsburgh's legendary sports moments. (Right, photograph courtesy of National Photo Company Collection Keystone View Co. Inc. of N.Y; below, courtesy of Photo Antiquities Museum of Photographic History.)

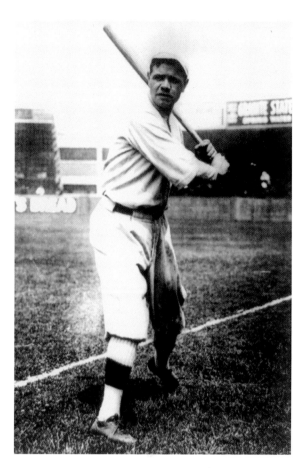

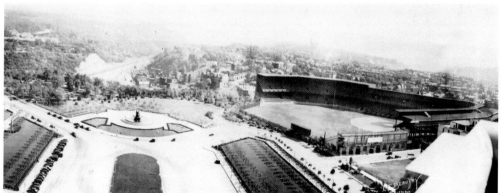

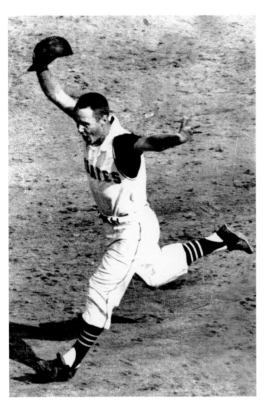

Pirates second baseman Bill Mazeroski was one of baseball's finest defensive players, but at 3:36 p.m. on October 13, 1960, Mazeroski's bat landed him into the pages of baseball history. This photograph shows a jubilant Mazeroski rounding second base after his ninth-inning home run off Ralph Terry in the seventh game of the 1960 World Series. The solo homer over the left field wall capped an improbable series win over the mighty New York Yankees and clinched Pittsburgh's first World Championship in 35 years. This moment was captured by *Post-Gazette* photographer James Klingensmith, who was granted access to the roof above the Forbes Field press box. Klingensmith's photographs of Mazeroski's World Series home run are on exhibit at the National Baseball Hall of Fame. Forty-one years after hitting that home run, Mazeroski himself was inducted to the hall. (Courtesy of James Klingensmith.)

A jubilant Bill Mazeroski heads for home plate as the Pirates pull the series upset over the heavily favored New York Yankees in the 1960 World Series. The gentleman directly behind Mazeroski is Dominic "Woo" Verratti, a Forbes Field usher. Twenty-five years earlier, Verratti was among a group of boys in Oakland who retrieved Babe Ruth's 714th and final home run ball. With the help of Pirates announcer Bob Prince, the boys donated the ball to the National Baseball Hall of Fame and Museum. (Courtesy of James Klingensmith.)

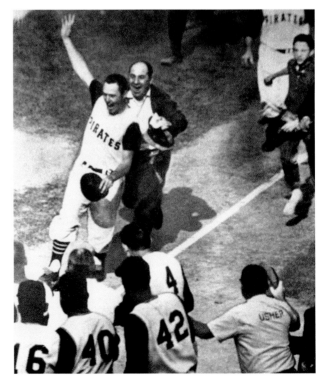

BRAGGING RIGHTS

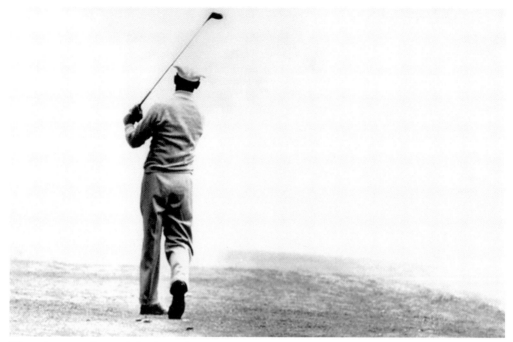

This photograph is of the legendary Ben Hogan in action at the 1953 United States Open Championship at Oakmont Country Club. Hogan was acknowledged by many as the best golfer of his era, and ranks as one of the greatest in the history of his sport. Hogan's 1953 U.S. Open win at Oakmont was part of a dominating season in which he won five of the six tournaments he entered, including the first three majors of the year. (Courtesy of Oakmont Country Club.)

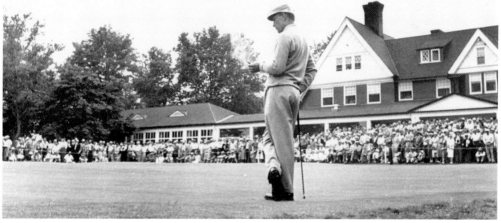

Hogan pauses during play at the 1953 United States Open Golf Championship at Oakmont Country Club. Introduced in 1903 by designer Henry Fownes, Oakmont Country Club in Pittsburgh has hosted more major championships than any other course in the United States. Including the 2007 U.S. Open, Oakmont has hosted 17 major championships (eight U.S. Opens, five U.S. Amateurs, three PGA championships, and one U.S. Women's Open). The Women's Open in 2010 will bring that total to 18 majors! (Courtesy of Oakmont Country Club.)

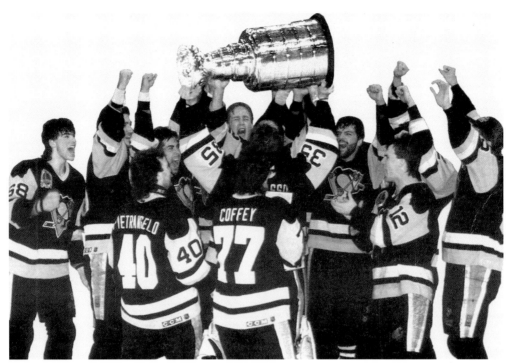

The Pittsburgh Penguins won hockey's Stanley Cup two years in a row in 1991 and 1992. This photograph captures the jubilant image of the team hoisting the trophy overhead. (Courtesy of General Mills.)

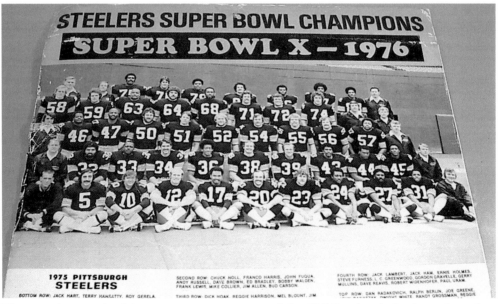

This is a photograph of the commemorative poster of the 1975 Pittsburgh Steelers taken when they became the National Football League's Super Bowl X Champions in 1976. (Courtesy of Lisa Alzo.)

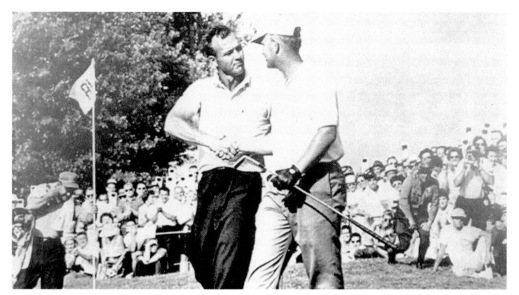

Arnold Palmer and Jack Nicklaus had one of the fiercest rivalries in all of sports. Their head-to-head battles began at the 1962 U.S. Open championship at Oakmont Country Club, where Nicklaus defeated Palmer in an 18-hole playoff. At Oakmont, Latrobe native Palmer enjoyed a hometown advantage, but Nicklaus earned his first professional tournament win, and the first of his 18 majors. Palmer and Nicklaus transformed golf into a television sport, bringing the competition from America's country clubs to America's living rooms. Palmer and Nicklaus turned golf into a spectator sport and ignited a worldwide interest in the game. (Courtesy Oakmont Country Club.)

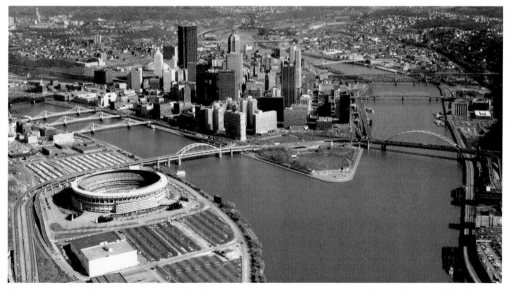

No other city of comparable size has had such success in sports at the professional level than Pittsburgh. The city earned bragging rights and the nickname "City of Champions." (Courtesy of Photo Antiquities Museum of Photographic History.)

www.arcadiapublishing.com

MAP SEARCH

Discover books about the town where you grew up, the cities where your friends and families live, the town where your parents met, or even that retirement spot you've been dreaming about. Our Web site provides history lovers with exclusive deals, advanced notification about new titles, e-mail alerts of author events, and much more.

MADE IN THE USA

Arcadia Publishing, the leading local history publisher in the United States, is committed to making history accessible and meaningful through publishing books that celebrate and preserve the heritage of America's people and places. Consistent with our mission to preserve history on a local level, this book was printed in South Carolina on American-made paper and manufactured entirely in the United States.

This book carries the accredited Forest Stewardship Council (FSC) label and is printed on 100 percent FSC-certified paper. Products carrying the FSC label are independently certified to assure consumers that they come from forests that are managed to meet the social, economic, and ecological needs of present and future generations.

FSC
Mixed Sources
Product group from well-managed
forests and other controlled sources

Cert no. SW-COC-001530
www.fsc.org
© 1996 Forest Stewardship Council

Find Your Place in History.